CW00521848

JOHN KIPPIN
CHRIS WAINWRIGHT

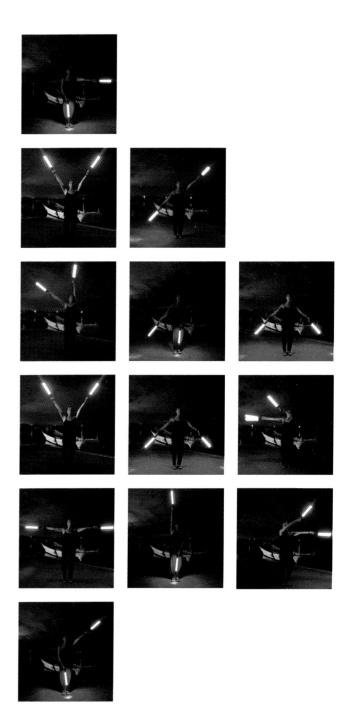

Chris Wainwright
<
Futureland Now
Aomori, Tōhoku Region, Japan
>
Futureland Now
Pett Level, UK

JOHN KIPPIN
CHRIS WAINWRIGHT

FUTURELAND NOW

Edited by Liz Wells
With an essay by Mike Crang

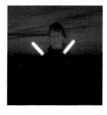
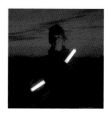

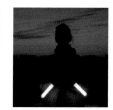
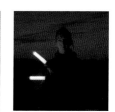

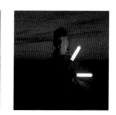

UPP
University of Plymouth Press

Chris Wainwright
Communication Alien Northumberland, UK
Inkjet print on paper, 1988/2012

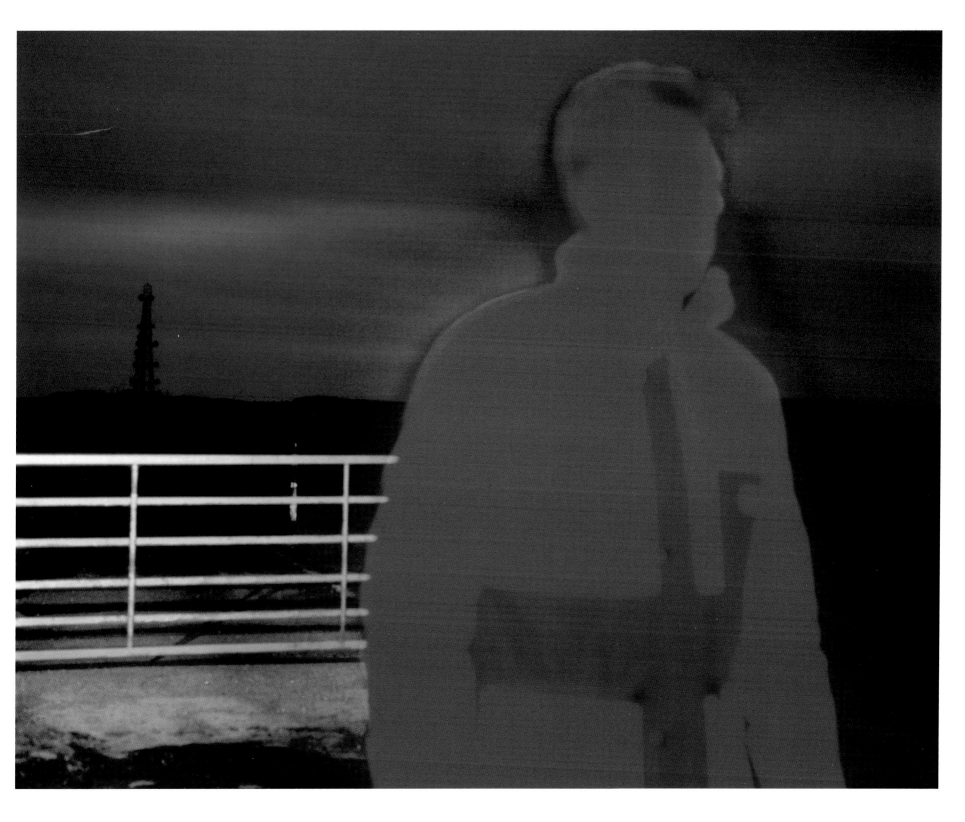

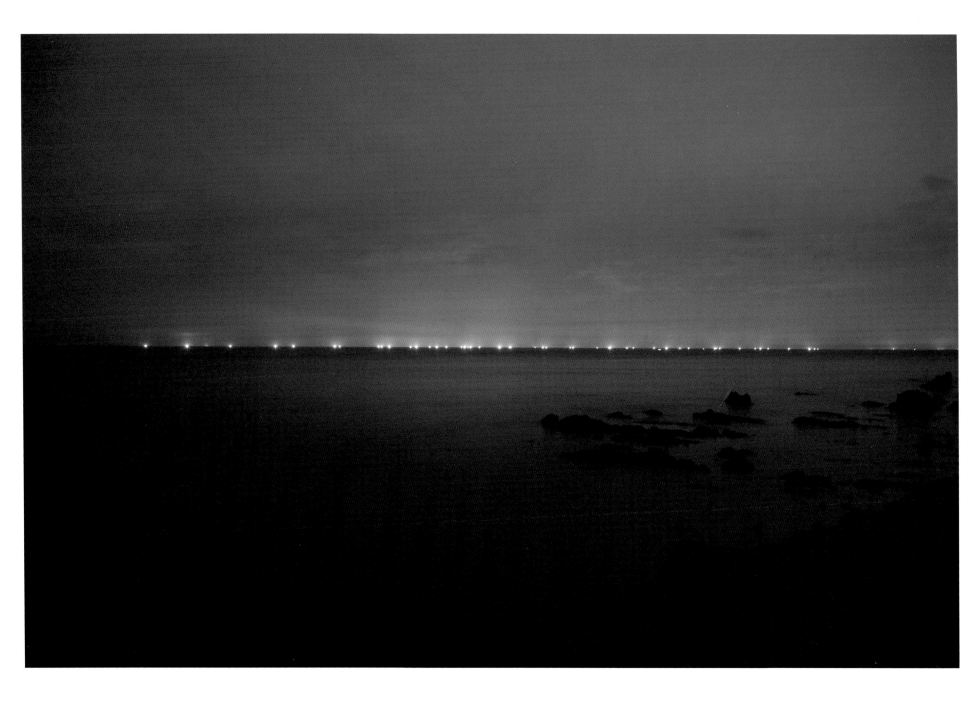

Chris Wainwright
Fishing Fleet on the Sea of Japan Aomori, Tōhoku Region, Japan
C Type print on aluminium, 2009

CONTENTS

John Kippin
ENGLISHISTORY, 1988/2012
Inkjet pigment print on paper, 40 x 32"

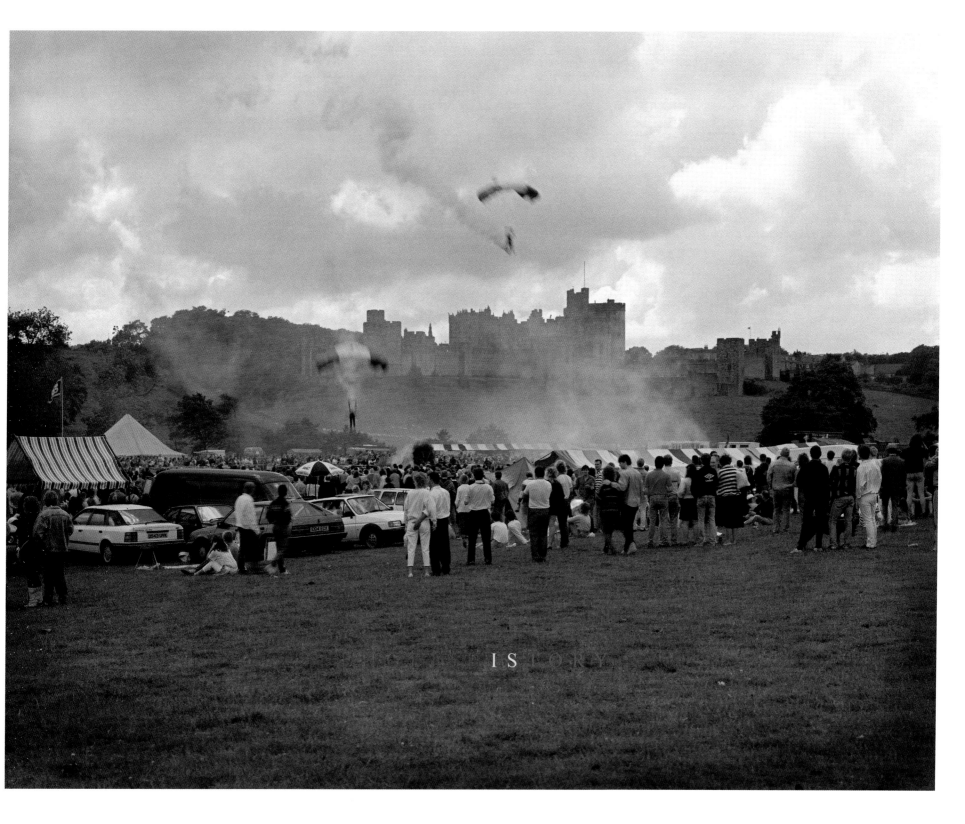

FOREWORD

Julie Milne
Chief Curator of Art Galleries
Tyne and Wear Archives and Museums
Laing Art Gallery, June 2012

Futureland, shown at the Laing Art Gallery in Newcastle Upon Tyne in 1989, was an exhibition of monumental colour photography by John Kippin and Chris Wainwright that represented the social and economic upheavals of the 1980s and its potential future ramifications. Both artists were among the pioneers of new British colour documentary and in the 1980s both lived in the North East. At that time, the production of large-scale colour prints for an art gallery exhibition was unusual, indeed controversial, and *Futureland* was a key component in the re-evaluation of the aesthetics of British photographic and fine art practice. It engendered a new understanding of the importance and potential of landscape as a tradition in British art that could provide a means with which to discuss a range of political and social issues. Indeed, writing the catalogue introduction to *Futureland,* T. Dan Smith peers into a crystal ball "towards a clear day view of what 'society 2000' might indeed, could, be like."[1]

1 T. Dan Smith, Introduction, *Futureland* exhibition catalogue, Laing Art Gallery 1989

The current economic situation closely parallels that of the 1980s with a world recession and banking crisis that has contributed loss of job stability with the possibility of many years of economic uncertainty. Kippin and Wainwright invoke the language of the sublime to explore this postmodern period of potentially seismic change. It is timely that the new exhibition of their work *Futureland Now* engages with these debates offering a catalyst for discussion and reflection, together with the development of a critical art practice that is relevant within a changing contemporary context. Both artists have continued to develop new aesthetic and philosophical responses. These are represented through a range of innovative approaches to the contemporary northern landscape.

John Kippin
LAUNCH, 1991/2012
Inkjet pigment print on paper, 40 x 32"

Although the images largely focus on the North East, the issues they address have a national and international dimension.

The context of the art gallery was and remains central to the understanding and interpretation of this project. Kippin's and Wainwright's work has a strong resonance with the Laing's historical collection. A significant proportion of the gallery's contemporary commissioning has focused on the concept of the sublime, most notably inspired by the work of 19th century British Romantic painter John Martin. Alongside this, the Northern Spirit permanent gallery celebrates the art of the North East and includes work by regionally and internationally important artists, telling the story of the lives of artists and their relationship to the region, exploring the themes of artists and communities and river and city as important signifiers of regional identity. From visitors, there is a palpable sense of pride in this identity and in the quality of the art collection that prompts it. Kippin's and Wainwright's practice weaves fluently through these fine art traditions and the themes of identity based on regionality; their photographic work is akin to romantic landscape painting in forming reflections of contemporary society while, crucially, offering a critical challenge to some of the more comforting narratives and representations of the past and the North East that are also evident in the Laing's collection.

Some 24 years after T. Dan Smith's metaphorical crystal ball gazing, the predictions made in the work of John Kippin and Chris Wainwright have been affirmed. *Futureland Now* provides a local as well as globally relevant response to the uncertainty and immense change that infuses our present day experience. The exhibition is both a catalyst for reflection on the past and a farsighted indication of an ambiguous and indefinite future.

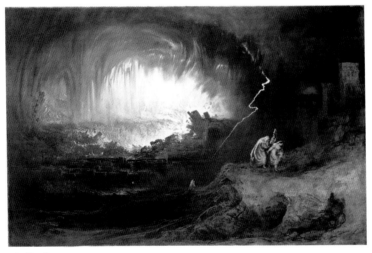

John Martin
The Destruction of Sodom and Gomorrah, 1852
Painting, oil on canvas
Laing Art Gallery, Tyne & Wear Archives & Museums

Chris Wainwright
A Long Way from China Metro Centre, Newcastle Upon Tyne, UK
Inkjet print on paper, 1989/2012

Chris Wainwright
Tyneside Development Newcastle Upon Tyne, UK
Inkjet print on paper, 1989/2012

>
Chris Wainwright
Wearside Industrial Development Zone Sunderland, UK
Inkjet print on paper, 1989/2012

>>
Chris Wainwright
Wearside Industrial Development Zone 2 Middlesborough, UK
Inkjet print on paper, 1988/2012

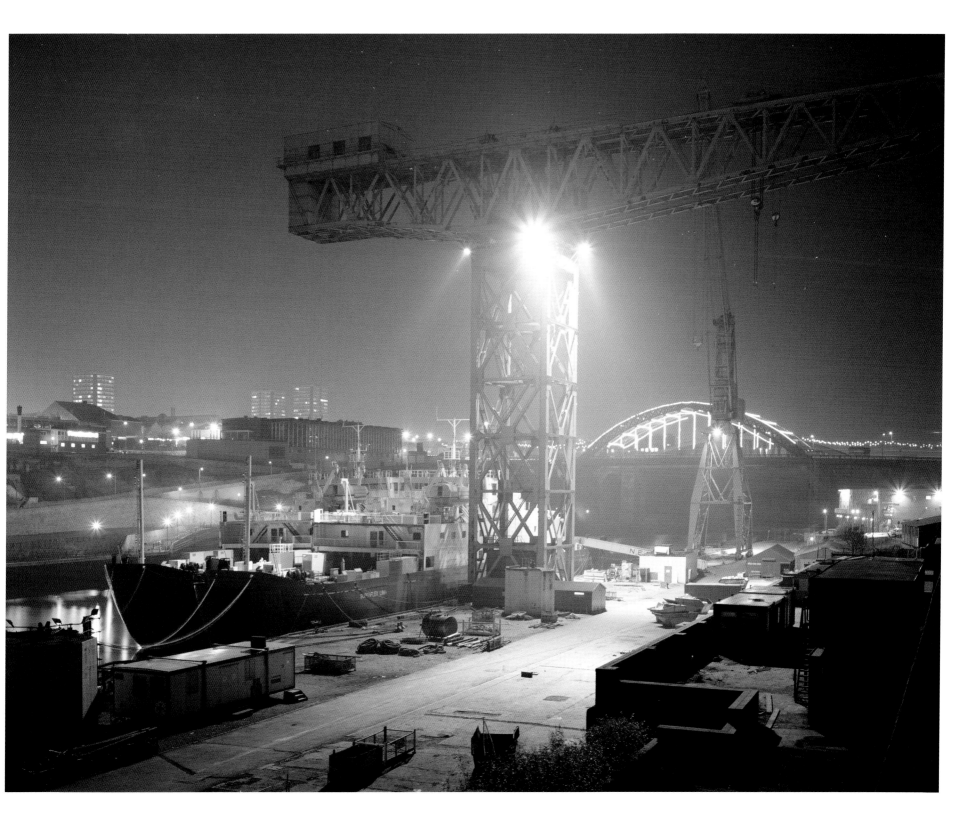

John Kippin
INVISIBLE, 1988/2012
Inkjet pigment print on paper, 40 x 32"

>
HIDDEN, 1988/2012
Inkjet pigment print on paper, 40 x 32"

>>
CIRCLING, 1990/2012
Inkjet pigment print on paper, 40 x 32"

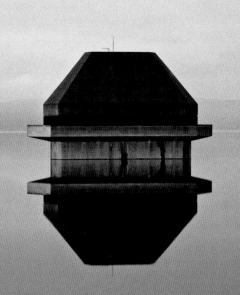

INVISIBLE

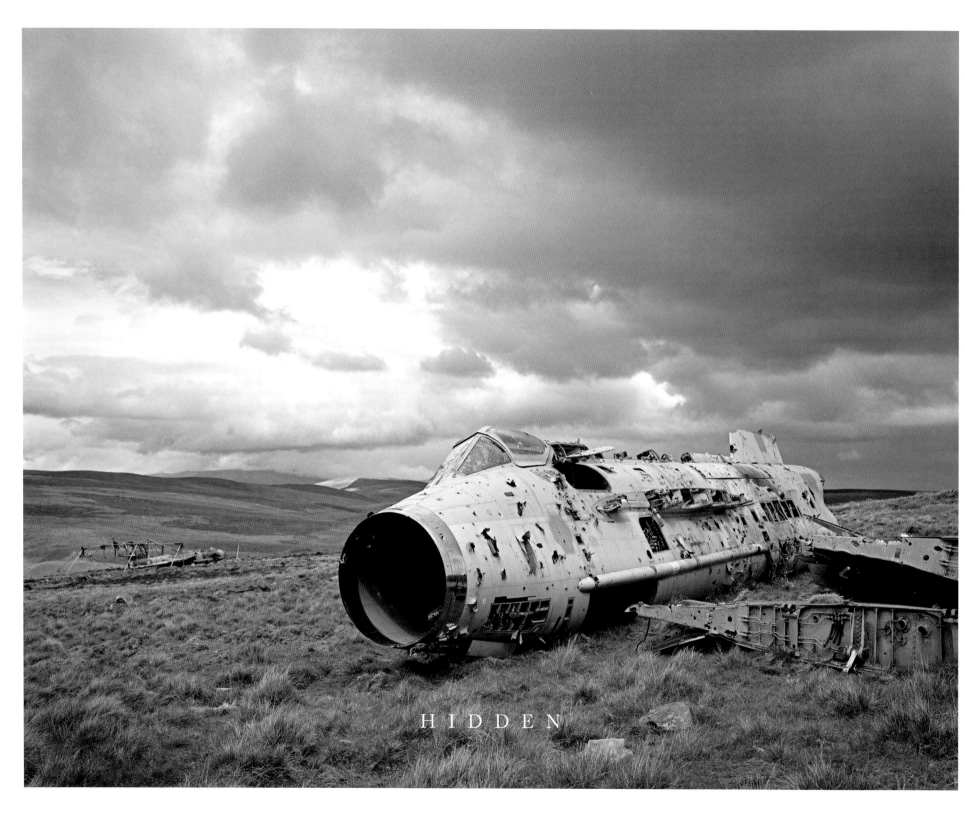

HIDDEN

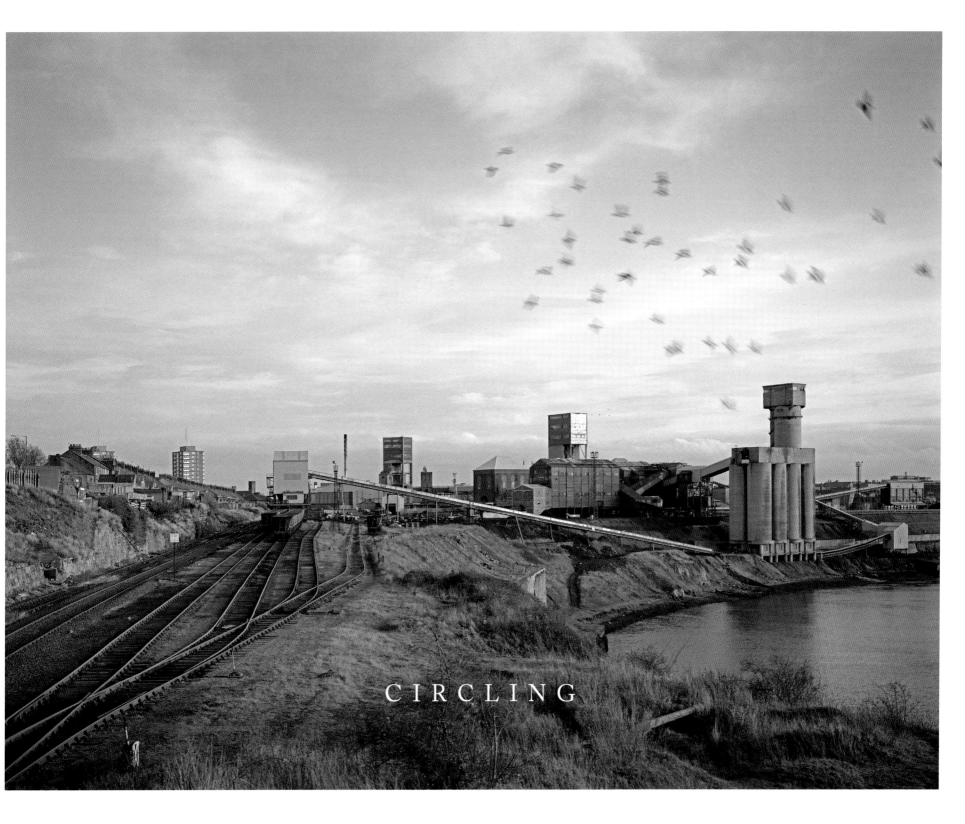

CIRCLING

Chris Wainwright
Phantom National Park Northumberland, UK
Inkjet print on paper, 1988/2012

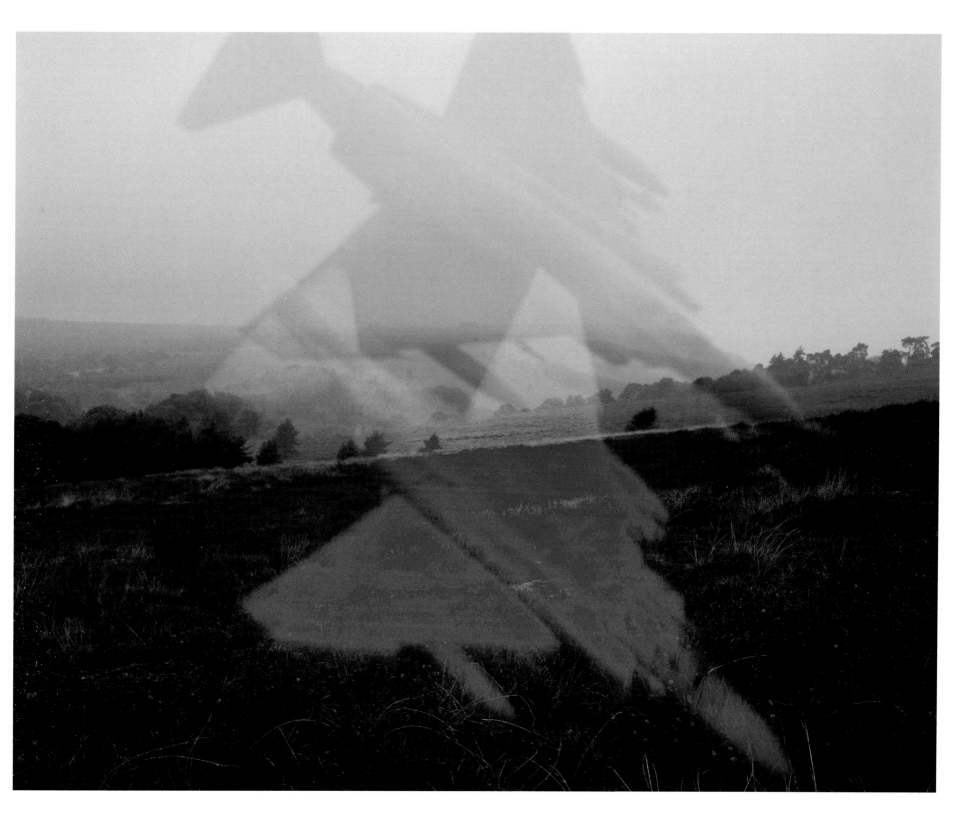

Chris Wainwright
Teesside Middlesborough, UK
Inkjet print on paper, 1988/2012

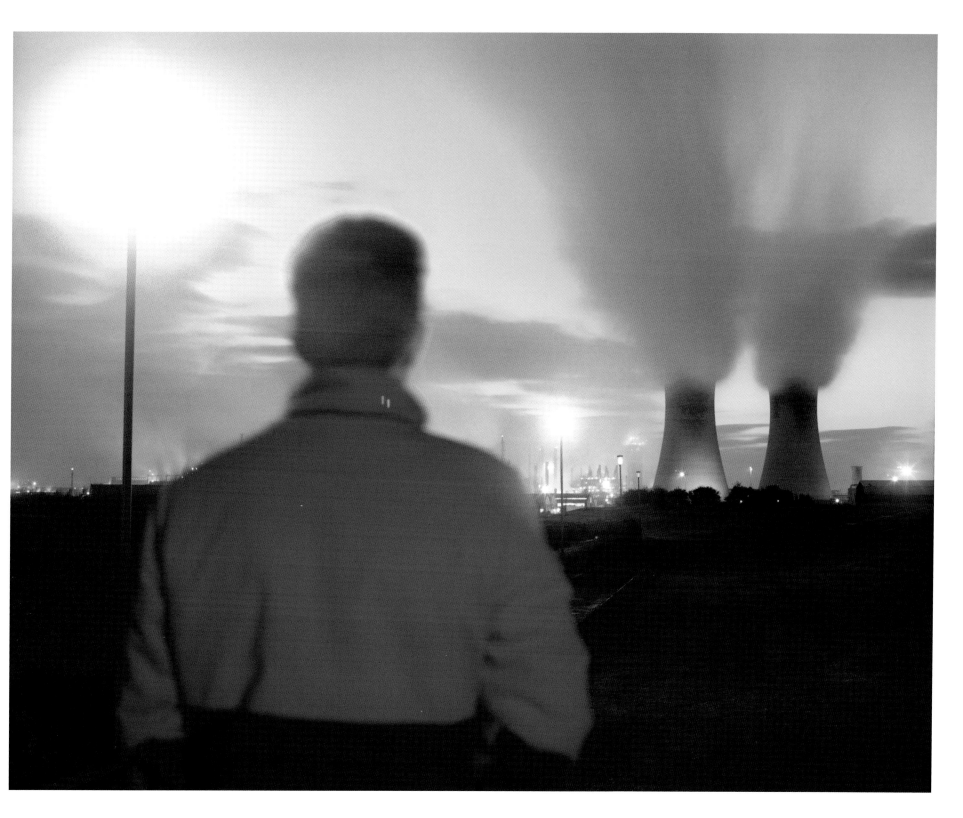

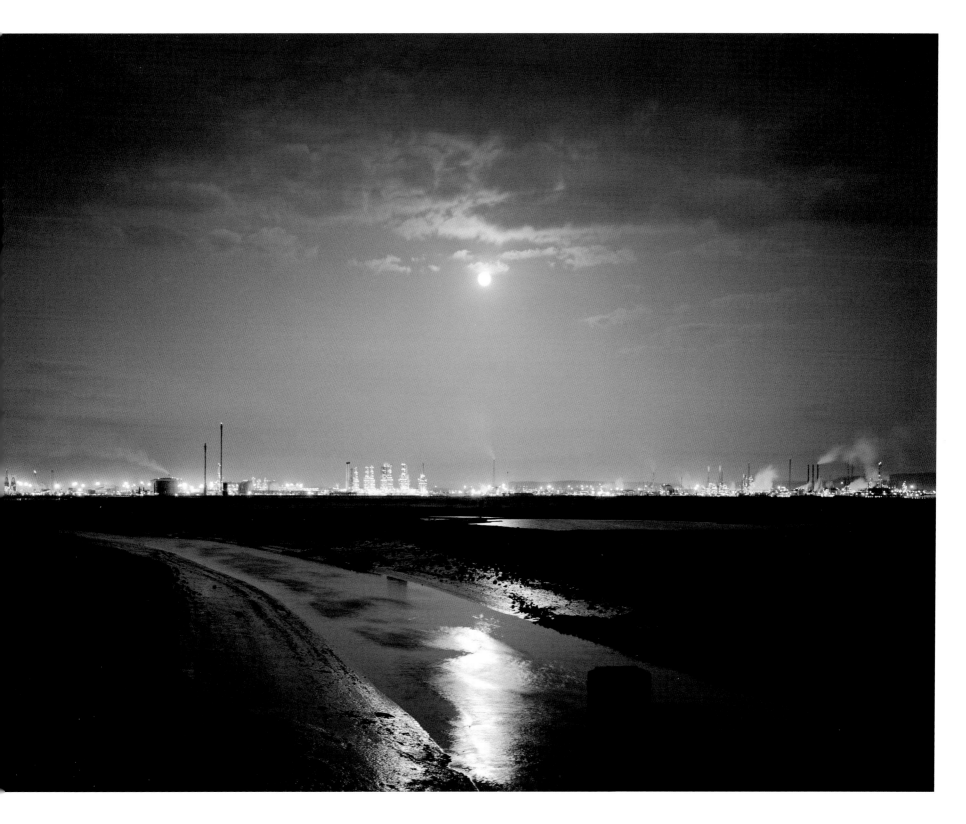

POINTS OF DEPARTURE: CURRENCIES OF THE POST-INDUSTRIAL SUBLIME

Liz Wells
Professor in Photographic Culture
Plymouth University

Art is risk made visible.[1]

John Kippin and Chris Wainwright experiment in modes of photographic practice. In *Futureland Now*, they re-visit places and issues that they first explored in the 1980s, and that continue to preoccupy each of them. My title, 'Points of Departure', references the artists' questioning of starting points, methodologies and approaches to research and communication through art. Historically, it also references the industrial economy of the North East of England. Ports linked by river to cities such as Newcastle, Sunderland and Middlesbrough had expanded and mechanised due to world trade, becoming points of departure and arrival for cargo boats transporting people, goods and raw materials internationally. Nineteenth-century colonialism and industrialisation were inextricably interrelated.

1 Email signature of artist-photographer Arno Rafael Minkkinen.

The artists focus on the North East, where both were living and working in the 1980s, and where post-industrial shifts and decay were particularly marked. However, questions raised through their work relate to other regions in the UK and elsewhere in Europe – Clydeside, Belfast, Avonmouth; Rotterdam, Marseilles. Given the global relocation of centres of industrial production, especially to Asia, formerly thriving harbour areas fell into decline. In many cases, (in the 1980s/90s) estuary warehouses were used for enterprises such as temporary galleries and artists' studios. Now, often through public partnerships with property developers, most have been transformed into marina housing and leisure areas, albeit often including arts initiatives (for example, in Gateshead, the Baltic Centre

Chris Wainwright
Looking for Ships Near Sunderland Whitburn, UK
Inkjet print on paper, 1988/2012

for Contemporary Art, and the Sage Music Centre). Such transformations symbolise a shift from industrial production as the primary economic base to secondary economic activities led by public-sector provision (including museums and galleries, hospitals, schools, universities) and consumer-service sectors. Associated with this has been the loss of cultural affiliations such as trades union clubs, traditional workplace networks and camaraderie. Practical skills and family relations typical of the industrial era have also disappeared as sons and daughters no longer follow fathers, mothers and grandparents into factories or onto the docks.

My primary concern is not with the geographies of industrial heritage – discussed by Mike Crang (page 61) – but with processes of investigation, response and communication through visual practice. My focus is on thinking through art, photo methodologies, aesthetics and contemporary currencies of the sublime, particularly notions of industrial and post-industrial sublime.

SUBLIME AS CONCEPT
In order to consider what is meant by 'industrial sublime' and 'post-industrial sublime', it is useful to return to the origins of 'sublime'. This first emerged as a notion referencing astonishment at the momentous in nature and we can remind ourselves of some of the several strands of thinking about our relation to environmental phenomena that have preoccupied aesthetic philosophers.

The sublime in art has been particularly associated with aspects of nature that are dangerous, beyond our control. Often cited examples from painting include the mists rising up the mountains in *The Wanderer above the Sea of Fog* by German artist, Caspar David Friedrich (1817/18) or many of the works of J.M.W. Turner – who famously tied himself to a ship's mast in order to experience storms phenomenally. The writings of 18th century German philosopher, Immanuel Kant, remain central – and contentious – within aesthetic theory as do the existential propositions of French thinker, René Descartes. Preceding Kant, Descartes insisted upon the separation of the mind and the senses, arguing that the relationship between thinking and being is fundamental: "I think therefore I am". In this

formulation, humankind is considered as apart from other species, cast in the role of rational observer rather than as integrated within natural ecologies. Descartes is particularly relevant to aesthetic philosophy for his binary distinction between the subjective act of looking, and object that is perceived. This obviously relates to analysis of painting or photography in terms of point of view, optics and cultural perception, in other words, ways of seeing. Kant's model fits with the Cartesian formulation in that the human ego and consciousness is centrally situated. In particular, Kant distinguished between evidence based on sensual experience – sight, hearing, etc. – and conclusions reached through philosophic reasoning deriving from the particular system or philosophic method as much as from actual experience. For Kant, mind, and the human power of analytic reasoning, was more important than material experience; in this model, the sublime relates to incomprehensibility, that which cannot be understood through *rational* measurement or debate.

Kant's formulation is distinct from – although often associated with – that of Irish philosopher, Edmund Burke. Burke defined 'beauty' in terms of matters of taste, of cultural acceptability. For him, beauty was considerably less momentous than the sublime. We are not astonished by beauty; we enjoy it, but we take it in our stride. In his treatise, *A philosophical enquiry into the origin of our ideas of the sublime and the beautiful*, Burke particularly distinguished between pleasure and pain asserting that pain is the stronger emotion:

> "The passions which belong to self-preservation, turn on pain and danger; they are simply painful when their causes immediately affect us; they are delightful when we have an idea of pain and danger, without being actually in such circumstances; this delight I have not called pleasure, because it turns on pain, and because it is different enough from any idea of positive pleasure. Whatever excites this delight, I call sublime. The passions belonging to self-preservation are the strongest of all the passions." (Burke 1759:47)

Given our instinct for self-preservation he suggests that death is the one thing worse than pain. In an arts context, it is the notion of pleasure in *vicarious* experiences of pain or danger that is of interest.

Burke adds:

"The passion caused by the great and sublime in nature, when those causes operate most powerfully, is Astonishment; and astonishment is that state of the soul, in which all its motions are suspended, with some degree of horror.... Astonishment... is the effect of the sublime in its highest degree; the inferior effects are admiration, reverence and respect." (Burke, 1759:53)

In Burke's formulation, we are so overcome by an object or experience that we lose our reasoning abilities, hence we experience the sublime as 'irresistible force'. He clearly states that nothing 'so effectively robs the mind of all its powers of acting and reasoning as fear'.

We tend to associate the sublime with scale, but the sublime relates more to a sense of threat that may emanate from natural phenomena, for example, gales or storms at sea, or the sheer extent of a mountain range. Fear is not induced simply by that which overwhelms in terms of monumentality or wildness; it also relates to familiarity or unfamiliarity. In Freudian terms, sublimation references that which we unconsciously opt to repress (especially that which is difficult to reconcile with our sense of self or of how we ought to feel, behave and respond in given circumstances). Mountains that we may find awe-inspiring are everyday summer workspaces for shepherds. Likewise, cultural artefacts, such as the feats of engineering implicated in industrial environments, may come to seem everyday although, given pause for reflection, they are equally astonishing. Indeed, cultural perceptions are socio-historically specific. The sublime is not inherent to phenomena that astonish us. Rather, the sublime emanates from our responses, for instance, to the implications of human action past and present.

The key point is that the sublime is an effect of representation, of the virtual, of phantasy, rather than of actual danger. The post-modern French thinker, Jean-Francois Lyotard, has commented that the Kantian formulation discounts what for him is a key point in Burke's analysis, namely that, "...the sublime is kindled by the threat of nothing further happening." (Lyotard, 1991:99). This is not as paradoxical as it might seem. In other words, he reminds us that we are free to enjoy an image or an experience because there is *no actual*

terror; rather, an allusion which induces a sense of awe occurs in the symbolic order. Things may be momentarily astonishing, but they are under control; we do not have to engage directly with them. To experience a massive storm at sea is terrifying. Enjoying an imaginary set of circumstances represented in art or literature is a sublime indulgence, albeit one that may remind us that we live in hazardous circumstances and in an environment that we do not control. Sublime imagery surely epitomises the notion that 'art is risk made visible'.

Perhaps one of the key differences between now and the pre-industrial 18th century, when Burke and Kant were debating ideas about beauty and the sublime, is that then there was a view of the natural world as somehow apart, God-given. For the Romantics, this was a space of gentle replenishment. Romanticism, from the late 18th century onwards, responded to industrialisation and urbanisation, through harking back to earlier historical eras, particularly associated with classical (Greek and Roman) civilisations, and also through conceptualising the natural world as a particular type of space of solace and spiritual replenishment (Hobsbawm, 1962). Now we have a more holistic understanding of humans and the natural world of which we are a part. Human action has consequences. Many contemporary writers and artists, including Kippin and Wainwright, variously engage with this. In effect, they are making work that questions whether we will accept responsibility for our impact on nature, at what cost to ourselves if we do, and at what cost to ourselves if we don't?

CURRENCIES OF THE POST-INDUSTRIAL SUBLIME

If the classical sublime references our responses to nature, then industrial sublime refers to our astonishment at the form and scale of activities implicated in factory based production plants and processes, including subsidiary older occupations such as mining or boat-building that expanded to support 19th century entrepreneurship and the new spirit of modernity. The Capitalist model is simple: machinery and labour transform raw materials into saleable assets; the lower the costs (wages, research and development, investment in technology, transportation of goods, etc.) and the higher the sales price, the greater the profit margin for the owner/employer. The wheels of Capital are oiled by the profit-motive of the entrepreneur for whom

the process, when it works well, is elegant. Such entrepreneurial developments were socially transformative.

When Friedrich Engels, son of a German textile manufacturer, worked in Manchester, in 1842, in the English branch of the family firm, he undertook a study of the living conditions of the working classes. In effect, he noted the consequences of the concentration of industrial labour for urban life, critically commenting on health and poverty. Likewise, strolling the streets as a *flâneur* in the mid 19th century, and writing about the expansion of Paris and the new central boulevards, the French critic Charles Baudelaire was excited by the city as a modern, energetic, social and political hub (Baudelaire, 1863). Baudelaire's focus was on bourgeois culture, including street life, by contrast, Engel's concern was with living conditions, but the investigations of both were prompted by social change. Baudelaire also acclaimed artists, such as the painter Edouard Manet, for their focus on modern life; art played a key role in witnessing and reflecting upon the pace and form of social developments.

In Britain, artists documented and variously expressed responses to engineering achievements, including the railways, steam transport, canals and bridges over waterways that constitute the inland infrastructure for shipping port operations. Retrospectively, the range and diversity of work may not easily be characterised as a specific art movement, by contrast, for example, with Impressionism in France. Artistic styles and themes were diverse as were the responses expressed. Where in *Rain, Steam and Speed* (1844) J.M.W. Turner celebrated the power of steam as the train cuts through the storm, Ford Madox Brown's *Work* (1852–65) depicted a chaos of craftspeople engaged in different forms of labour.[2] John Martin, a key historical painter from the North East, created sublime paintings on biblical themes that might also be taken allegorically to refer to anger at the industrial ambitions of modernity. For instance, *The Great Day of His Wrath*, (1851–53) depicts a city being torn up, and *The Destruction of Sodom and Gomorrah* (1852) shows Lot and his daughters rushing from the scene; an Old Testament story, referencing

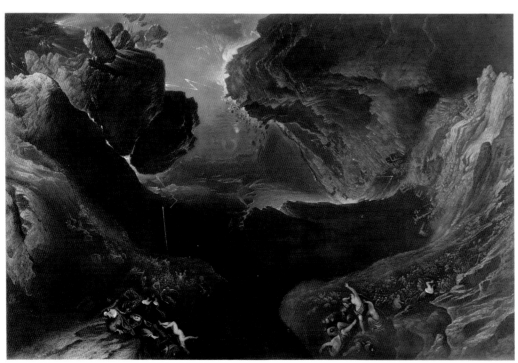

John Martin
The Great Day of His Wrath, 1857
Print made by engraver Thomas Maclean for John Martin
Shipley Art Gallery, Tyne & Wear Archives & Museums

2 J.M.W. Turner, *Rain, Steam, and Speed – The Great Western Railway*, 1844, Oil on canvas, 91 x 122 cm, The National Gallery; Ford Madox Brown, *Work*, 1852–65, oil paint 137 x 197.3 cm, Manchester City Galleries.

cities destroyed as a punishment for immorality. By contrast, in his *Industrial Landscape* (1955), L.S. Lowry details an urban geometry of factory roofs and chimneys, in effect, a topographic investigation within which the presence of the industrial is normalised.[3] We might

3 John Martin, *The Great Day of His Wrath*, 1851–53, Oil on canvas, 196.5 x 303.2 cm, The Tate Gallery; John Martin, *The Destruction of Sodom and Gomorrah*, 1852, oil on canvas, 136.3 x 212.3 cms, The Laing Gallery/Tyne and Wear Archives and Museums; L. S. Lowry *Industrial Landscape*, 1955, oil on canvas 114.3 x 152.4 cm, The Tate Gallery.

also reference Bill Brandt's photo-story *Below Tower Bridge* that includes images of places such as *The Wharves at Wapping* or an apparently disused factory in Nightingale Lane (Warburton, 1993:66/73). Perhaps because his work was generated for photo stories about people, places and circumstances, rather than as single images, the number of photographs that he made in industrial locations is easily overlooked. My point is that, although the term 'industrial sublime' dates from the 1980s, enquiry into the socio-spatial effects of factory organisation and transportation systems is much longer standing. But it is only with the benefit of hindsight that 'industrial sublime', like 'modernity' and social change in the 19th century, became identifiable as a clear cultural lineage within visual arts practice.

Art continues to engage with the contemporary. 'Industrial sublime' was a novel phrase in the 1980s that became incorporated as a sub-genre of landscape photography, urban as well as rural. In some respects, it is a very British genre (although not confined to British landscapes). As engineers of the industrial revolution, legacies of industrialism are historically deep-seated and therefore marked in Britain; visible evidence includes the expansive system of canals linking rivers for transportation of goods, the railways that came later, and the factories and warehouses that accumulated along the various waterways. Northern cities such as Manchester and Newcastle expanded exponentially in the Victorian era. Waterside areas facilitated movement and warehousing of fuel (coal) and raw materials for industrial production, whether regionally sourced or imported (cotton, rubber, non-native wood, and so on) and it is no accident that factories were developed along the banks of rivers and canals. Likewise, it is no coincidence that industrialisation and the British Empire were concurrent; they were fundamentally

interrelated as colonialism facilitated access to raw materials. For Britain, as an island, shipping was the only means of international communications. Hence coastal ports harboured larger ships for passenger transport, mail, and movement of personal goods, alongside docks for cargo vessels.

Industrial decline became a focus for Left politics of the 1970s and 80s in Britain. In some respects, debates romanticised an industrial past in ways that ignored the real historical relations and experiences of factory and shipyard work, although the desire to retain jobs, wages and familiar employment structures (however hierarchical and/or draconian) is understandable. But in terms of radical art practices there was an address to that which had been repressed, for instance, in the industrial landscapes documented by Lowry, the engineering achievements celebrated by Turner, or Martin's more cataclysmic allegorical response to industrialisation and urbanisation. A more complex post-modern critique re-framed the ambitions, achievements, losses and class relations of modernity. Many artists became interested in the histories associated with former industrial sites, ghosts of the past made manifest for present reflection. For example, John Podpadec's photomontage series on mining in South Wales, made at the time of the miners' strike, referenced work conditions, decay and industrial injury historically. (Podpadec, 1985:20/21) Likewise, Alison Marchant's installation, *Wall paper History*, 1988, which was one within her larger Heritage series, drew upon anonymous pictures and diaries to relate stories about industrial work conditions and the famous 1888 strike by Bryant and May's match girls – the women employed at the matches and match-box factory in East London.[4]

4 See *Variant*, No. 5, Summer/ Autumn 1988, p. 15.

Significantly, in terms of post-industrial redevelopment of former factory and warehouse areas, this site was one of East London's first gentrification projects; it was renamed Bow Quarter (an act of labour history erasure) and today encompasses private flats, landscaped gardens, a gym and pool, a restaurant and shop.[5] Artists were exploring legacies and transformations dating

5 http://www.foxtons.co.uk/property-for-sale-in-bow/chpk0301833 (1 July 2012).

from the industrial period, hence 'industrial' sublime; although perhaps *post*-industrial would have been more accurate as the phrase

was coined to express something about legacies of the industrial era, not to mention cultural histories involving economic transformations and social change.

Futureland, first staged in 1989, was in tune with questions that were being asked at the time, an era of political tension in Britain. (Margaret Thatcher was Prime Minister and the government mission included reducing the influence of the trades unions.) The exhibition also represented the Laing Gallery's contribution to celebrations marking the 150th anniversary of photography in Britain. In keeping with the Gallery's standing collection in which the North East is foregrounded, the exhibition was intended to bring the region into contemporary focus. But the curator demonstrated broader awareness through selecting two artists whose approach to photographic practices is always experimental in terms of aesthetics, whilst socio-politically grounded in terms of places and themes, albeit not necessarily explicitly so. Both artists took the opportunity to explore new ideas and new picture-making methods, seeking points of departure for making work that would somehow engage themes differently thereby enhancing rhetorical impact. In this respect, their work is in distinct contrast with the explicit story-telling mode of social documentary. The artists picture legacies of industrial arrangements – dockside warehouses at night (Wainwright), rusting cargo ships (Kippin) – juxtaposing this with, for instance, shopping malls, thereby referencing the move towards consumption as a newly prioritised economic force. A shift made visible.

So the post-industrial involves a re-evaluation of the industrial with the benefit of hindsight. In terms of landscape aesthetics, post-industrial explorations transcend the topographic, with artists operating not as observers but as *investigators* of land, culture, place and identity in terms of socio-historical formations. That this implicates enquiry into the sublime is indicated in the titles of many recent publications: *Vanishing Landscapes*, *Transformed Land*, *Imaging a Shattering Earth* (Barth, 2008; Baillargeon, 2005; Mah, 2011). Likewise, writings about work by artists such as Edward Burtynsky, whose profile rests on his interrogation of new industrial landscapes, include references to 'toxic sublime', 'terrifying prospects', 'ecological disasters' and 'atrocity aesthetics'. (Battani, 2011; Cammaer, 2009; Giblett 2009; Peeples, 2011.) Waste disposal, gas emissions and other toxic hazards, are side effects of industrial concentration as is the pollution caused by transport infrastructures reliant on extracted fuels such as coal and oil. Over the years, there has been extensive discussion of risks associated with living near nuclear power plants, chemical factories, and so on. Waste may be visible but toxicity usually is not, so it can be challenging to find ways of conveying risk photographically. Yet there is a sense of urgency: artists are rethinking the sublime in ways that side-step or transcend legacies of both Enlightenment thinking and Romanticism, so that nostalgia for a particular type of past is replaced by a more critical questioning of legacies that often interrelates past, present and future. This may also include reflections on the import and impact of digital technologies, and also research into dystopian consequences of industrialisation, particularly climate change. As Allan Sekula has suggested, we are not so much in an era of the post-industrial, as in one of globalisation facilitating a re-location of the industrial (Sekula, 2001). But if, as I have suggested in relation to the Burkian sublime, the effect is context specific, then it is conceptually possible for the industrial, the post-industrial and the technological to co-exist as sources of wonderment, although differently inflected according to contextual histories and specificities. Kippin and Wainwright are among many artists who have engaged questions formed in part through reflecting upon the post-industrial West as related to emergent industrial centres elsewhere.

New technological developments are integral within this. Hence, an interest in the technological, including our awe at achievements in electronic communications. In many respects, the welcome we accord to the technological is similar to that of 19th century entrepreneurs advocating industrialisation and, later, Fordism (assembly line modes of factory organisation). Contemporary skeptics are viewed as the Luddites of the 21st century. Yet, where the industrial was once a matter of celebration, it now gives us cause for concern, certainly in terms of environmental trauma. On the basis of previous experience, in welcoming the electronic revolution, new technological achievements and looking to the future with high expectations, a

note of caution might be advisable. For example, there is now a space observatory at the South Pole, which until very recently was one of few remaining wilderness areas. There are several telescopes, scientists and support workers who live there for extended periods of time, planes fly in and out, provisions arrive and waste has to be removed, and the US has built a roadway across the Antarctic ice which can be reopened each summer (the Northern Hemisphere's winter) for transport of equipment, laying of power lines, and so on. The Hubble Space Telescope is used to investigate outer space, the landscape frontier of our time, but at what environmental cost?

The changes are complex. The relocation of industrial centres has been partly enabled by the communications revolution. As we know from everyday encounters, such as phone calls to service centres or help lines, new technologies are also integral to global employment shifts within service sectors. Multinational corporations have been quick to take advantage of cheaper labour costs and less-stringent regulation in newer industrial regions. Although many in the West debate the toxic- and climate-related consequences of industrial pollution, 'advanced' nations nonetheless evacuate redundant ships and other waste to breakers yards located in poorer regions and take advantage of the cheaper prices facilitated in industries such as clothing or electronics. This is despite questions raised by campaigners, and even some governments, concerned at further pollution of waterways and increases in toxic emissions globally.[6] In China, extensive urbanisation and industrialisation may be acclaimed, or may be accepted as simply the next step within a long march forward. Yet, sociopolitically this is complex, with many differing interests at stake. The coverage of the Three Gorges dam project in 2011, including the number of photographers who travelled to China to document changes along the Yangtze River, testifies to international interest and concerns.[7] This suggests a continuing fascination with the industrial sublime.

6 See the United Nations Framework Convention on Climate Change. http://unfccc.int/key_documents/the_convention/items/2853.php (June 2012).

7 Examples include projects by Edward Burtynsky, www.edward burtynsky.com; Steven Benson, www.stevenbensonphotographer. com; Nadav Kander, www. nadavkander.com.

Simultaneously, we may wonder at technical phenomena, often taking on board new developments in ways rather akin to Alice's acceptance of strange events during her journeys in Wonderland. It is as if nowadays little is left that surprises, although were we to pause to reflect on it, much of everyday experience is somewhat sublime. For example, my Apple laptop, designed in the US, assembled in China in order to maximise factory line skills and take advantage of non-union labour, is leased by the University that employs me under a rental contract that allows regular updates. Via codes founded in mathematic principles that I do not understand, the computer allows me access to a virtual environment that is so extensive and fluid that it would defy cartography should anyone ever consider attempting this. I have become dependent on Internet access in ways that I should find astonishing that should also give me pause for thought, given the extent to which the virtual world has become a site of exchange that is fought over in terms of freedom of information, democratic debate, censorship etc. Mostly, I just use it. I can logon, seek out cameras based in the South Pole, and reflect on how momentous the space of Antarctica is and the fact that I can view this live from home. I can shop online internationally or, via Google Earth, operate as a virtual *flâneuse*. All this ought to be utterly astonishing, but astonishment is somehow neutralised through the apparent ease of access. We marvel at technological change, and then it comes to seem normal.

THINKING THROUGH ART

"Futureland is an exhibition of innovative large-scale colour images by John Kippin and Chris Wainwright. Through their images, they question and challenge social and political issues which are vital to an understanding of the present situation. These issues include unemployment, state control, regional stereotypes, militarism, consumerism and the exploitation and distortion of our heritage. Although located largely in the North East, where the artists live and work, these striking images give a national dimension to such major issues."
(Collier, in Kippin & Wainwright, 1989: Foreword)

Mike Collier, curator at the Laing Art Gallery when *Futureland* was staged there in 1989, clearly situates the exhibition within a national

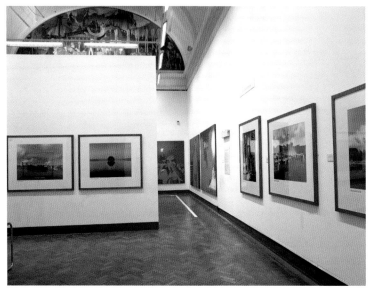

social context. As he suggests, for artists concerned with the implications of post-industrial shifts, the key challenge is to find aesthetic strategies that both allow themselves as researchers to think through art and invite similarly critical responses from audiences. Post-industrial sublime references a realm of questioning that also allows for experimentation in arts practices. What is it that is so astonishing and why was this not previously remarked?

Wainwright and Kippin were pioneers in reflecting on the post-industrial shift and also on how to convey something of the enormity of shifting socio-economic circumstances. Kippin's work was often referenced as contributing to the new British colour documentary movement of the 1980s. Wainwright became known for experimenting in, then, new digital print methods. Both artists test new means of making work as well as varying contexts of installation. The wry and sometimes ironic texts placed within the images by Kippin in his series Nostalgia for

8 Initial examples were included in *Futureland*, 1989.

the Future was innovative at the time[8] (Kippin, 1995). His work became centrally associated with that of a number of other British artists working with photography, whose work came to be characterised as new British colour documentary. Imagery particularly pointed to legacies of the past as marked in the present, or reordered within, at the time a burgeoning 'heritage industry'. Some of his image-text montages are not particularly subtle, for instance, the use of red, white and blue for the text of ENGLISHISTORY/ENGLISH IS TORY; others are more elliptical so meaning is more fluid and viewers have to puzzle a little more. A key example would be the title image, with 'nostalgia' enigmatically referencing both the rusty boat and the notion of a family day out, epitomised by the caravan on the beach. Kippin no longer uses image-text in this way. If a strategy is used too often, or becomes too familiar, it loses its rhetorical impact. Exploring new strategies is imperative in order to retain both authority and cutting edge. His more recent work returns to the same subject but the mode of picturing is in some respects more forensic and more topographic; he currently constructs diptychs and triptychs, and thinks very carefully about visual juxtapositions within the image. He also uses video and in sound installation.

John Kippin
NOSTALGIA FOR THE FUTURE, 1988/2012
Inkjet pigment print on paper, 40 x 32"

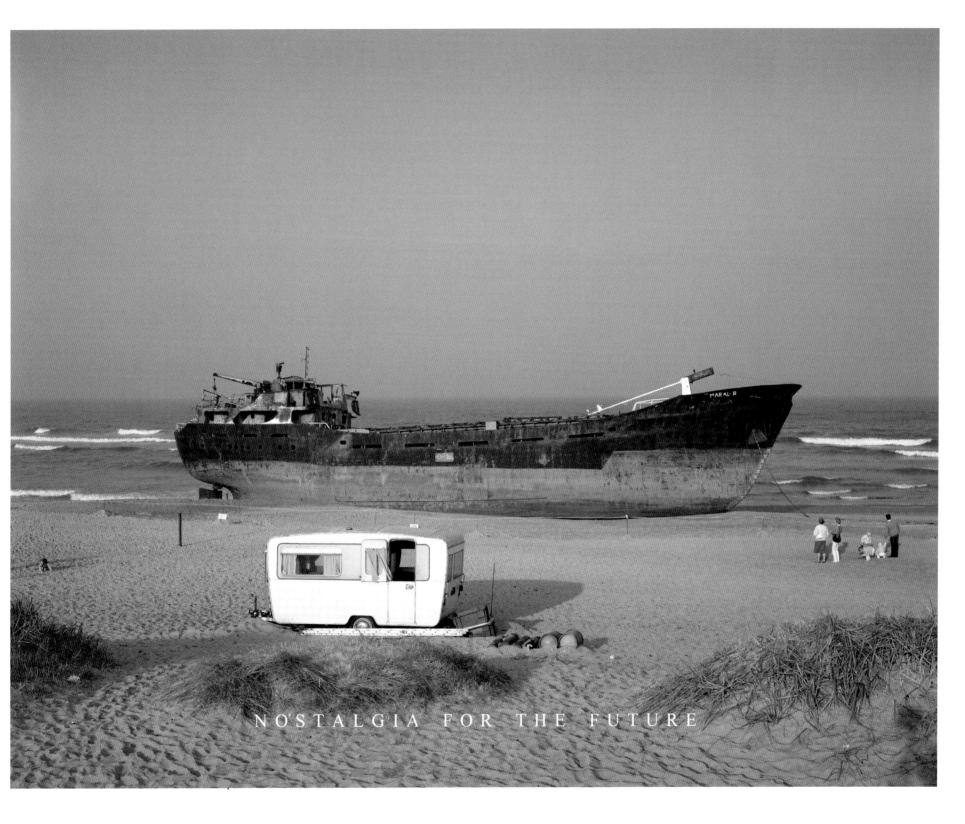

NOSTALGIA FOR THE FUTURE

Likewise, in The Navigation Series, Wainwright questioned the future for a region formerly centred on its rivers and shipbuilding, now being re-imagined in terms of service and heritage. The mode is elliptical: the shadowy red figures staged in former industrial sites suggest ghosts from the past echoing towards an unknown future. The series of seven images was also innovative in experimenting with a scanachrome printing method, now defunct, long superseded by newer digital processes that are nowadays orthodox. In terms of theme, Wainwright continues to explore the sea as a means of transportation for humans and materials historically and as an ecological system constantly in transition, most particularly as a result of global warming leading to climate change for which ice melt and changing water levels acts as an indicator. Red – a colour also characteristic of the work of the Victorian painter, John Martin, referenced above – frequently features within his imagery, often as an effect of torchlight 'painting' the sea, alerting us to look and reflect.

Discussing photography as contemporary art, Charlotte Cotton, curator and critic, uses the notion of 'deadpan' in relation to a new, and anti-humanist, 'turn' in documentary practices. Commenting on the 'monumental scale and breathtaking visual clarity' of gallery prints, she remarks that this is moving art photography "...outside the hyperbolic, sentimental and subjective." (Cotton 2004: 81). She cites Andreas Gursky and Edward Burtynsky as key instances of artists working with land and environment, but adopting a deadpan aesthetic. Both make pictures that reference the industrial, for example, Gursky's photographs of the Chicago Board of Trade, or the Hong Kong Stock Exchange, or Burtynsky's documentation of the transformation of the Yangtze River, or his more recent three part series, Oil.[9] Even though

9 Edward Burtynsky's series, Oil, is in three parts: Extraction and Refinement, Transportation and Motor Culture, The End of Oil. It was brought together from materials researched and photographed for over 20 years. Shown at the Photographer's Gallery, London, May–July 2012.

subjects may be emotive, the treatment is seemingly neutral. There is an ostensive democracy here: the artist-photographer presents a scenario as if simply mediating it for our response. As with any image there is a viewpoint, but the photographer's perspective is not fore-grounded. For Kippin and Wainwright, both of whom would describe themselves as artists working with photographic media,

not as photographers, this is precisely the limitation of documentary realism.

Kippin and Wainwright both work within the gallery context. For audiences, there is a reference to documentary as specific locations and histories form thematic starting points. As researchers they continue to explore new modes of photographic communication and their work always introduces an element of dissonance within the gallery context. Kippin increasingly explores the semiotics of scale and installation in gallery and site-specific locations. Recent work includes Coast, an exploration of change on the Essex maritime area, that was exhibited at the Minories Art Gallery, Colchester and subsequently at Jaywick, Clacton on Sea in the Martello tower (a Napoleonic fortress). It also includes Compton Verney, in which something of the atmosphere of this former family estate is conjured up through large-scale prints on canvas depicting empty reception rooms, small prints detailing nooks and crannies of staircases and cellars juxtaposed with medium-scale images of birds in flight, the trees and the lake for whom life continues well beyond the point when the estate ceased to be a family home. Wainwright now works in video as well as the still image, continuing to take travel, including movement of traffic at sea, as key themes. Red Sea includes a performance element as the water is 'painted' with light during the course of exposure. Some Cities particularly explores aesthetic effects of the diversity of artificial light that saturates contemporary urban centres. The series implicitly invites us to reflect upon the sensual congestion of such man-made environments. Both artists thus regularly engage and question landscape and environment through their respective practices.

Sea, ports, waterways and docklands form a key link between Wainwright's work and Kippin's. Within this, each artist deploys very different methodologies; varying thematic preoccupations and aesthetic concerns are also evident. Wainwright stages events. His images are pre-conceptualised, performed and tested. Kippin's pictures start as documents of places and moments of historical significance, which are re-inflected through processes of editing and captioning. On the relatively rare occasions when people appear within the frame in such a way that we know he will have had to ask

permission to include them, there is always a sense that the event would have occurred without the presence of his camera. He thinks through making pictures, with deep understanding of symbolic resonances. For example, at one level his video of *Ark Royal* leaving harbour simply records a stately naval ship being escorted out to sea by a pilot boat. But there is much more in play. For a start, *Ark Royal* was the fifth Royal Navy ship to carry this name, the first being the flag ship for the fleet that defeated the Spanish Armada in 1588, at the height of the first Elizabethan reign. Second, the ship was built by Swan Hunter on the River Tyne and launched there in 1981. As such, it references the significance of boat building as an industry for the region. Third, due to recent Ministry of Defence cuts, it was decommissioned in 2011, five years earlier than originally anticipated. A further symbolic blow to Tyneside pride! As to its future, possibilities under discussion include sinking it as a diving wreck in the 'English Riviera' of Torbay, a commercial heliport in London, a casino in Hong Kong or a school or nightclub in China.[10] Whatever the final decision, on the basis of these proposals an undignified future seems probable. So Kippin's video, at one level 'straight' documentation of a final departure, carries a range of historical references that together lend a wistful sense of pride and loss as this enormous ship dwarves its surroundings en route to its own transformation. Ironic, perhaps, that the ship's motto in naval times was 'Zeal does not Rest'!

10 See http://travel.aol.co.uk/2012/01/02/torbay-ark-royal-to-become-divers-paradise/; http://www.bbc.co.uk/news/uk-england-devon-16382411.

As the German dramatist Bertolt Brecht famously observed, a photograph can detail the outside wall of a factory, but that tells us little of the socio-economic relations that obtain within. Footage may show a ship leaving harbour, but this does not in itself say anything about the circumstances of its departure. The challenge to artists concerned with sociohistorical or with environmental issues is finding ways of moving beyond documentary that invite an audience to perceive and reflect on broader histories and circumstances beyond the image itself.

In the case of the *Ark Royal* video, the exhibition context is crucial. Kippin can be confident that the regional clientele of the Laing Gallery

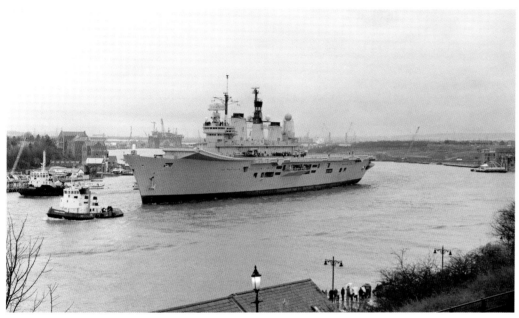

John Kippin
ARK ROYAL LEAVING THE TYNE, 2009

grasp the contemporary symbolic reference to ship building and industrial decline, even if they don't know of the link back to the Spanish Armada. Likewise, the triptych that depicts horses being ridden across the edge of the tide past coal shale deposits higher up the beach. Just in case you do not 'get it' from the image itself, the reference to mining, fuel and energy sources is re-affirmed through the caption, "BLAST FURNACE". The form of the imagery is traditional in terms of landscape aesthetics with the horizon centrally across the image, the riders caught centrally within the image, a sense of movement from left to right, the direction in which they are riding but also, of course, the direction in which we read. The work is in colour, but the tonal range is muted. There is no specific sense of location or precise date, even decade. As such it becomes a palimpsest referencing the pre-industrial past, within which horsepower fuelled agriculture and trade, together with the industrial as signified by the shale (a form of industrial waste) and with the future as the riders saunter forward.

At first glance, the rhetoric may seem to contrast hugely with the approach taken in a further image-text piece, 'AMERICAN COAL' in which we see a foreign barge travelling past a new housing estate located at the riverside, perhaps where warehouses once stood. The ferry leads the barge upriver, past houses with roof tiles in grey slate or terracotta orange, again, in this context referencing local industry, but as an example of 'coals to Newcastle' this image again offers a wry observation that references transformation and a sense of loss. The point is that the complex juxtapositions already exist; caught wryly within the same frame as a result of judicial selection of photographic viewpoint. The visual rhetoric is considerably more complex than it might first appear.

Chris Wainwright has a particular interest in former dockland areas and the post-industrial. Much of his work is made outside the UK, particularly in Asia, former Eastern Europe, and the Arctic, although he has also used moving imagery to explore the (former) docklands areas of the River Thames where he now lives. Thematically, he is particularly concerned with environmental decay; also with globalisation in relation to shifting economic structures but also

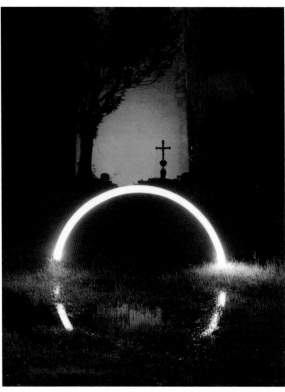

Chris Wainwright
The Church at the Centre of Europe Kremnica, Slovakia
C Type print on aluminium, 1994

the experiential. His approach is phenomenological. He notes: "Travel transforms us into anonymous strangers viewing the intensity of particular cities with fresh eyes, alert to detail that may escape attention in surroundings more familiar to us. The images detail effects of light and shade, often at twilight, noting human presence but emphasizing the sensual rather than the semiotic."[11]

11 Chris Wainwright, *Some Cities*, 2004 – artist's statement (for *Futureland Now* proposal). Also see www.chriswainwright.com.

Ensuing work is often relatively abstract, poetic, although the photographic origins imbue the images with reference to actual phenomena. He defines himself as an artist working with still and moving imagery. He works in colour, usually making large-scale pieces that respond to space, rather than detailing in any literal manner. Much of his work is opportunist in that, if he finds himself in a place (often due to his work in senior management within Higher Education) he will explore the city streets and waterways, often at night. In this respect his approach reflects that of Baudelaire's *flâneur*, wandering, observing and noting transient impressions of contemporary phenomena.

Other series are pre-conceptualised, often performance-based, involving some form of intervention such as 'painting' an environment with light, which is almost always red. Recent work from Arctic expeditions included sets of semaphore signals performed for the camera. Although the Arctic may seem far from post-industrial Tyneside, they are linked in terms of ice melt signalling global warming which is in part a consequence of industrial emissions. They are also linked through transportation systems. Semaphore, the optical sign system designed to convey short messages, for example, from ship-to-ship or from one hillside to another, predates Morse code (first developed for Samuel Morse's electric telegraph in the 1840s, and subsequently replaced by the international Morse code that has been used for radio communications since the 1890s). The principles are the same; a specific combination of arm (or flag) signals indicates a word.

In using semaphore, Wainwright references a mode of communication that was global, predates current digital communication modes, and, most particularly references seafaring. As with any coded system, it

relies on the familiarity on the part of those encoding and decoding for understanding what is being said (although in the gallery, for those not able to read semaphore, the message is in the caption). The coding operates literally as a method of inserting text within the image whilst linking this as a strategy which also becomes a motif, with his broader exploration of the affects of artificial light within natural twilight or moonlight, especially as the red light spills over to create a red line in the sand at the edge of the sea. A barrier? Danger alert? In one image the title, 'What Has To Be Done' references 'What Is To Be Done' by Joseph Beuys made in 1980. It was made at Aldeburgh, near Sizewell Nuclear Power Plant, in 2011 as a performance to celebrate what would have been Beuys' 90th birthday. (Beuys co-founded the German Green Movement in 1979, and, later, the German Green Party.[12]) In the gallery context, regardless of whether we get the reference to Beuys or can read the semaphore, once we have worked out that there is a coded statement, there is the related effect of starting to interrogate other images in terms of

12 Dates given are taken from 'Joseph Beuys and the Dalai Lama', interview with Louwrien Wijers, 1981, re-printed in Carin Kuoni, compiler, (1990) *Joseph Beuys in America*. New York: Four Walls Eight Windows.

systems of meaning, for instance, the lights of the fishing fleet at night suggest a Morse message where none is particularly intended. In essence Wainwright is concerned to respond to varying places as changing or fragile environments and to reference transformations wrought by human actions.

By contrast, John Kippin has worked mostly in Britain, using photography as a means of interrogating ways in which landscapes have been constructed and used. In many instances series have resulted from residencies, for example, exploring legacies of the US missile base at Greenham Common in Hampshire, or responding to Compton Verney, the large house in Gloucestershire that, significantly, was the venue for several appeasement negotiations in the run-up to World War II in Europe. Indeed, his work is always concerned with the sociopolitical and the economic, and ways in which histories resonate in the present, although the references are often indirect.

Kippin produces colour images for a gallery context and for book publication; he also frequently takes work out of the gallery, onto

hoardings or into public non-art gallery sites. He often incorporates texts, or uses captions not simply to anchor the meaning of the image but to extend it. Indeed, for both artists, contexts and modes of presentation are crucial. There is an enormous difference between the experience of viewing Kippin's or Wainwright's series as full-size exhibition prints, installations, or images on billboard hoardings and reproduced on a small scale, contained within a book, that may well have a different surface finish. Crucially, both books and galleries situate work within a broader context. The aesthetic pleasures, as well as the sociopolitical implications, are accumulative.

Given shifts in gallery practices and in technologies, features such as colour saturation, large-scale photography, and image-text integration that formerly had radical import in the original *Futureland* are now commonplace. Indeed, previous aesthetic tactics may now seem merely stylish or, even, outmoded. As is evident from *Futureland Now* as artist-researchers both Kippin and Wainwright constantly explore new modes of expression. As Brecht observed, "Reality changes; in order to represent it, modes of representation must also change." (Brecht, 1938: 492). As artists, both Kippin and Wainwright are always concerned with new points of departure.

References

Nadine Barth, Ed. (2008) *Vanishing Landscapes*. London: Frances Lincoln

Charles Baudelaire (1863) 'The Painter of Modern Life', in Baudelaire (1964) *The Painter of Modern Life and other essays*. London: Phaidon Press Ltd. Trans: Jonathan Mayne

Marshall Battani (2011) 'Atrocity Aesthetics: Beyond Bodies and Compassion' *Afterimage* 39: 1/2, July, pp.54-57

Claude Baillargeon, Ed. (2005) *Imaging a Shattered Earth, Contemporary Photography and the Environmental Debate*. Oakland: Meadow Brook Art Gallery, Oakland University and Toronto Photography Festival

Bertolt Brecht, (1938) 'Popularity and Realism' pp.489-493 in Charles Harrison & Paul Wood Eds. (1992) *Art in Theory*. Oxford: Blackwell Publishers

Edmund Burke (1759) *A Philosophical Enquiry into the Origin of our Ideas of the Sublime and the Beautiful*. Re-published (1990) Ed. Adam Phillips. Oxford: Oxford's World Classics. Based on the 2nd edition, 1759

Edward Burtynsky (2000) *Oil*. Göttingen, Germany: Steidl

Gerda Cammaer (2009) 'Edward Burtynsky's Manufactured Landscapes: The Ethics and Aesthetics of Creating Moving Still Images and Stilling Moving Images of Ecological Disasters'. *Environmental Communication* 3: 1, March, pp.121-130.

Charlotte Cotton (2004) *The Photograph as Contemporary Art*. London: Thames and Hudson. p.81

Rod Giblett (2009) 'Terrifying prospects and resources of hope: Minescapes, timescapes and the aesthetics of the future' in *Continuum: Journal of Media & Cultural Studies*, 23:6, pp.781-789.

Eric Hobsbawm (1962) *The Age of Revolution*. London: Weidenfeld and Nicolson. Ch. 14 'The Arts'.

John Kippin (1995) *Nostalgia for the Future*. London: The Photographers' Gallery; initial examples were included in *Futureland*, 1989.

John Kippin & Chris Wainwright (1989) *Futureland*. Newcastle: Laing Art Gallery

Jean-Francois Lyotard, (1991) *The Inhuman, Reflections on Time*. London: Polity Press, Originally published in French, 1988

Sérgio Mah (2011) *Terre transformée/Transformed Land*. Paris: Calouste-Gulbenkian Foundation

Jennifer Peeples (2011) 'Toxic Sublime: Imaging Contaminated Landscapes'. *Environmental Communication* 5: 4, Dec., pp.373-392

John Podpadec (1985) 'Mining in South Wales' *Camerawork* 31, Spring

Allan Sekula (2001)

Nigel Warburton, Ed. (1993) *Bill Brandt, Selected Texts and Bibliography*. Oxford: Clio Press. First published in *Lilliput*, March 1946

Liz Wells (2011) *Land Matters: landscape photography, culture and identity*. London: I. B. Tauris

Chris Wainwright
Channel Crossing North Foreland, UK
C Type print on aluminium, 2007

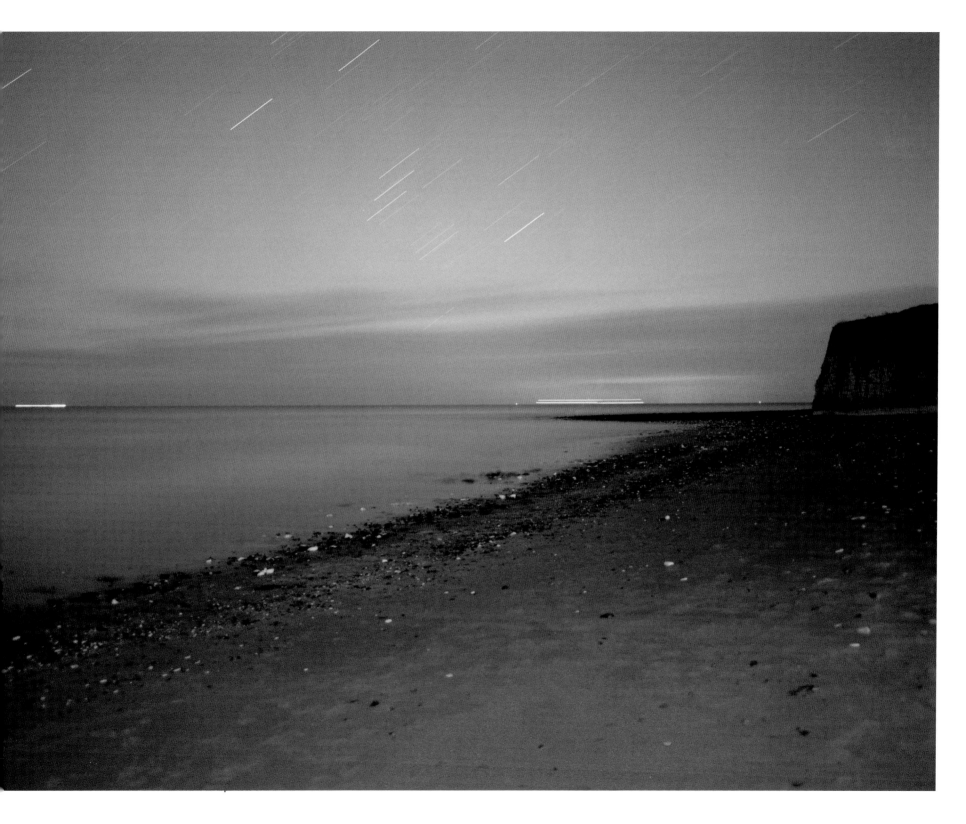

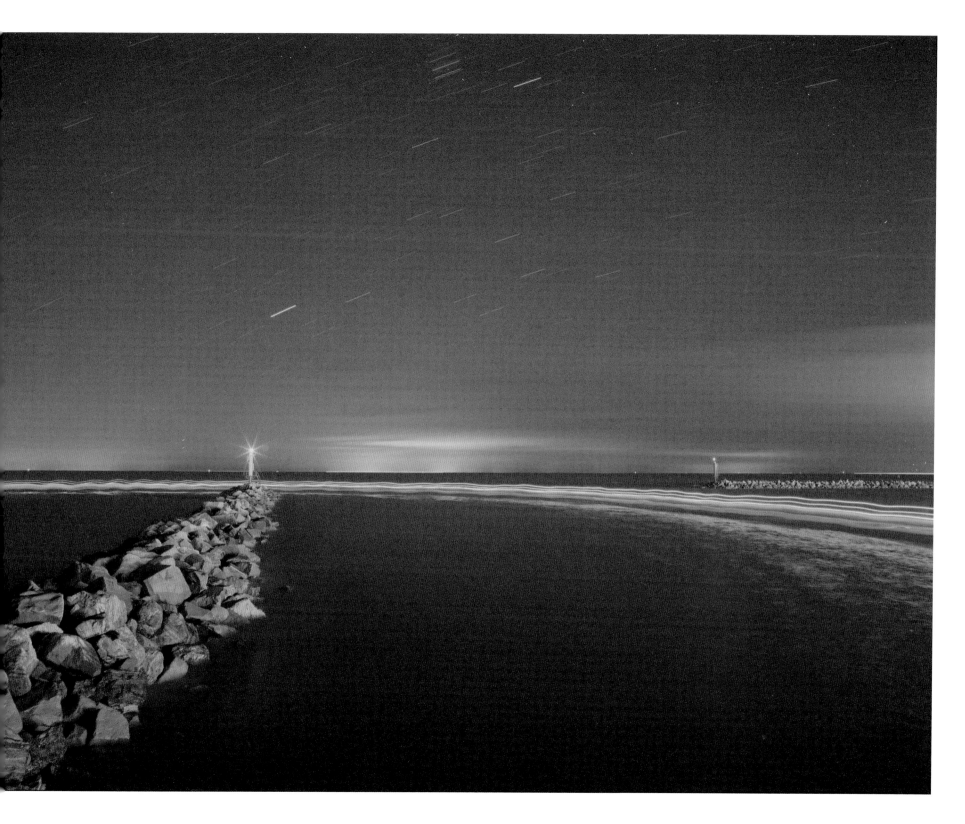

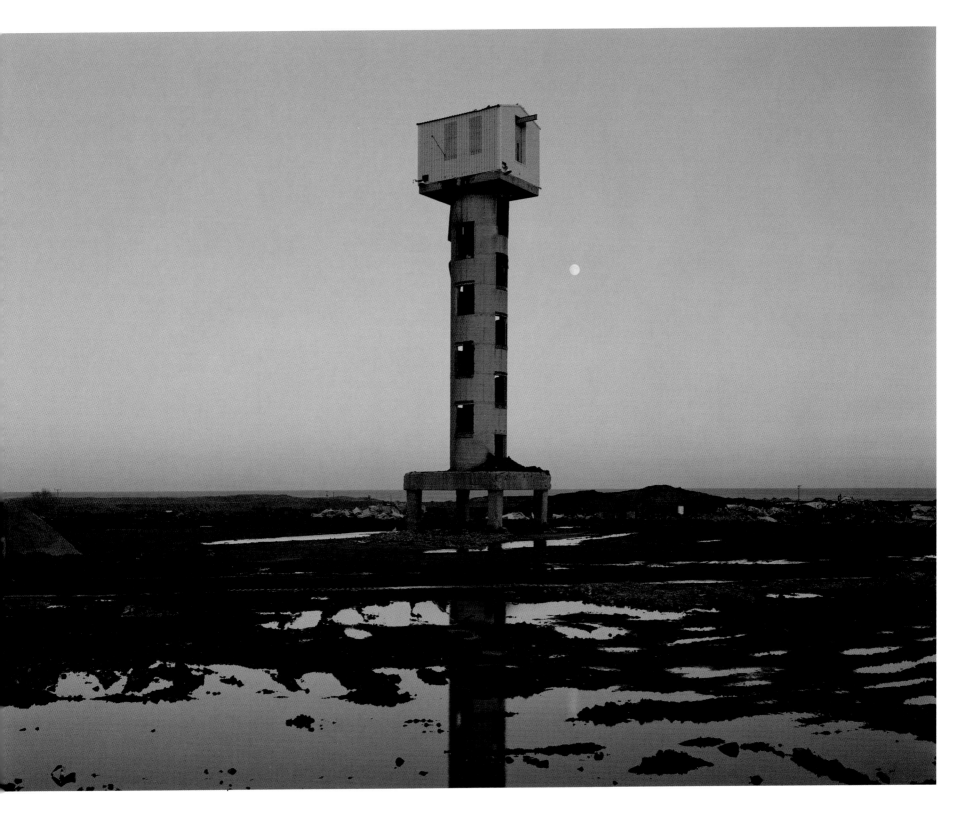

John Kippin
MISSING, 2010/2012
Inkjet pigment print on paper 40 x 32"

MISSING

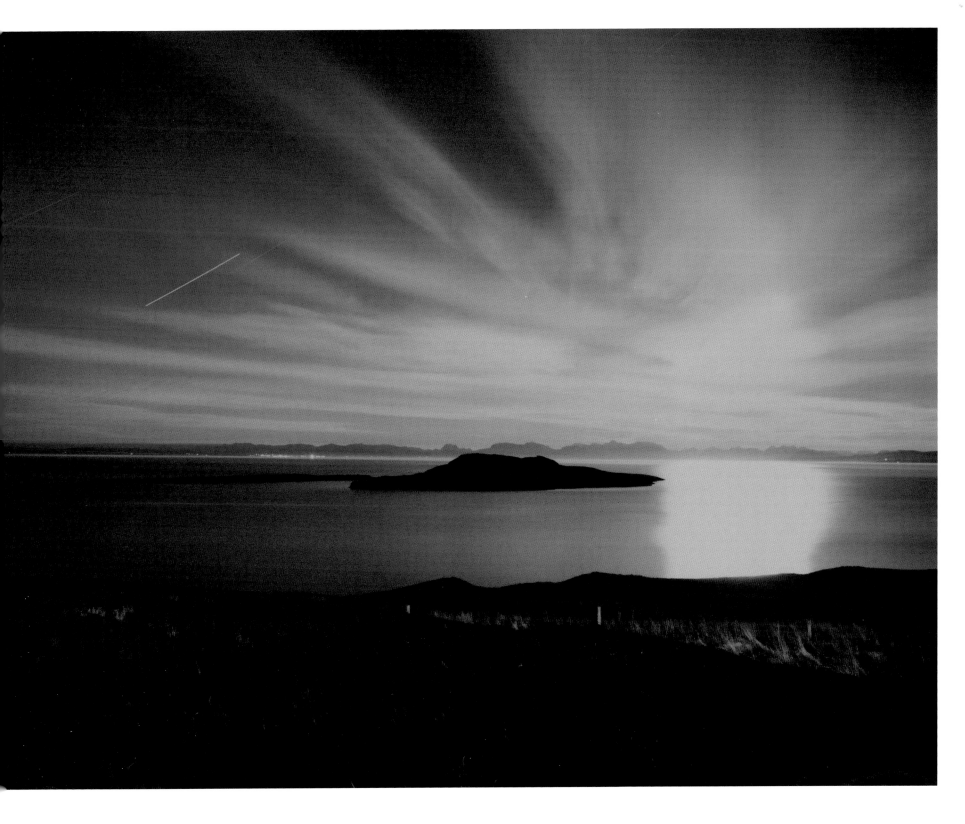

Chris Wainwright
What has to be done Aldeburgh Beach, UK
C Type print on aluminium, 2011

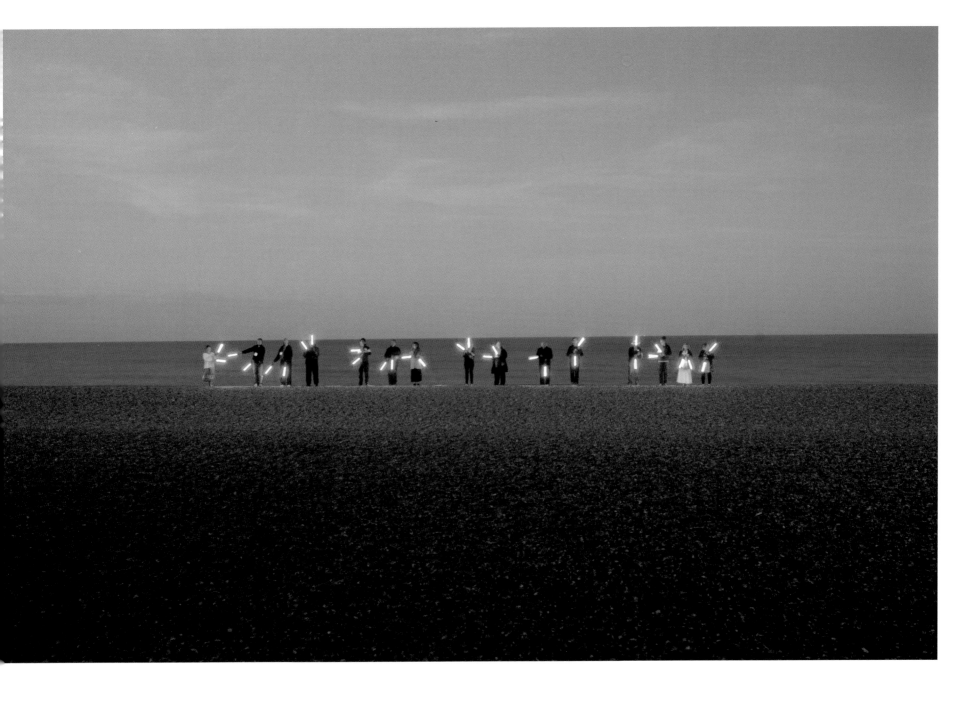

Chris Wainwright
Aftershock Rainbow Bridge, Tokyo, Japan
Inkjet prints on paper, 2012

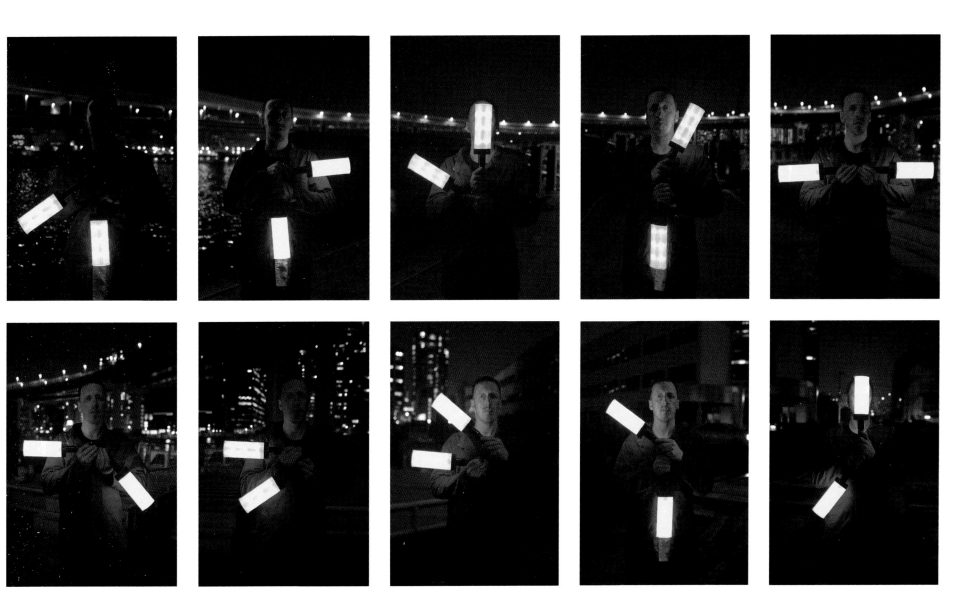

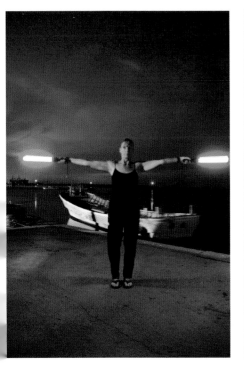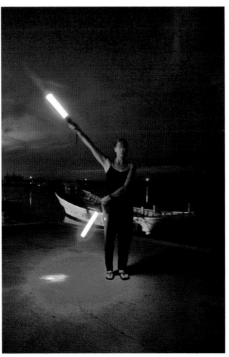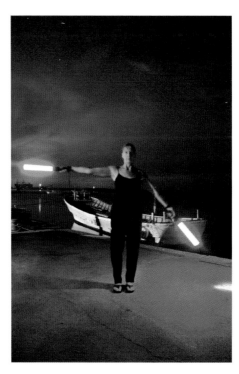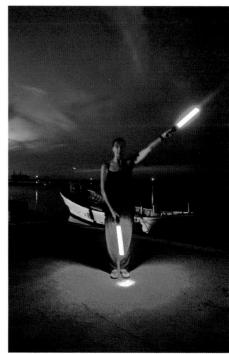

THE REMEMBRANCE OF NOSTALGIAS LOST AND FUTURE RUINS: PHOTOGRAPHIC JOURNEYS FROM COAL COAST TO GEORDIE SHORE

Mike Crang
Professor of Geography
Durham University

"The crisis consists precisely in the fact that the old is dying and the new cannot be born; in this interregnum a great variety of morbid symptoms appear."
Antonio Gramsci (1971)

"The future is but the obsolete in reverse."
Vladimir Nabokov (cited by Robert Smithson 1996:11)

In some way, photography seems an improbable medium for examining the future. It has long been associated rather with acts of remembrance and recollection. The photograph is so often the memento mori, the treasured relic of a lost loved one, of a time past. How then might photographs speak to the conflicted times of a landscape labelled post-industrial or de-industrialised? And how might such photography speak to the conditions of Northern England? Here it seems we are looking at a time and a place caught 'in-between'. There is an industrial legacy fading rapidly from sight and living memory; a landscape of industrial despoliation and dereliction that has been rapidly transmuted into a post-industrial consumerist landscape; and yet that consumerist future now seems like a future ruin – with developments and promises teetering on the edge of collapse, traces of what might have been. All this is occurring in a land that labels itself the 'North' in contradistinction to the powerful global City of London and the prosperous South and yet, is sandwiched between that and the culturally reassertive nation of Scotland to its own north. A region whose self-identity is founded on an industrial era, whose prosperity and produce were deeply connected

John Kippin
FORT GEORGE, 1991/2012
Inkjet pigment print on paper 40 x 32"

Through these pictures there runs not so much the industrial sublime as the 'ugly' and spoiled (Brady 2010). This is not the terrible, or even the toxic, sublime of nature or industry where the effect is one of awe and terror at the scale or power of the industry and its effects for better or worse (Diehl 2006). It is not a terrible beauty but an aesthetic appreciation of difficult, awkward and indeed ugly landscapes. The raw edges here resist the taming of the pastoral, resist a narrative closure in terms of final decline and abandonment. But these are pictures where their now-known future marks the scene as out of kilter – with an, as yet invisible, end haunting the view.

LANDSCAPES OF ERASURE AND INDUSTRIAL REMAINS
Such pictures remind one of Robert Smithson's framing of 'the memory traces of an abandoned set of futures' in post-industrial decay. His photographic project for the *Monuments of Passaic*, has the industrial effluent pipes of the Jersey shore becoming a fountain monument, and the industrialised coast gets mapped as a kind of archaeological park of ruins yet to be, where industry is already set up as though in a picture of future (Smithson 1996:72). Smithson's works often either referenced, or were sited, at abandoned industrial sites, so that even his famous *Spiral Jetty*, which is often depicted in isolation, is actually set in what he called an industrial wasteland, and his work points to processes by which nature re-colonizes such sites (Maskit 2007:328,30).

In Germany, amid the remains of a chemical plant, Thomas Jorion (2010) relishes the strangely vibrant colours that show aberrant life and development – even where the green pigments on a second floor office wall are matched by the incongruous and lush growth of grass across its floor. For Jorion, such sites show a society that discards and builds anew, leaving some places 'frozen' in time, even as society seems to accelerate. His pictures of 'closed rooms' offer us once lively places that appear as lifeless or, perhaps better, to be on 'standby'. And yet peering in we find them following a temporal flow all of their own that seems distorted or 'elongated' compared to the rest of the world. Here then, are the unintended monuments of industrial heritage that speak to a time out of joint.

The coast of County Durham was renowned for bearing the scars of mining. It was this kind of landscape and spoil that John Davies pictured through the Murton colliery slag heaps. Here photography recorded less the life of miners and workers, less the signs of industry, than the marks it left. Deep coal mining as an actual activity is, after all, hidden underground and all that is visible is detritus and waste (Byrne and Doyle 2004:172). The black coast of Durham was so named from the tons of coal spoil that spilt upon it. A coast where for 150 years waste was simply dumped on the beach, piling up to 30 feet deep in places. Estimates say up to 1.5 million tons was tipped on the coast each year – added to by locals for whom the coast became a simple dumping ground. Its eerily lunar landscape meant it appeared less in regional guides than as the baleful scenery for murder in *Get Carter* and indeed as an alien world for the film *Alien3*.

Yet, it is far from a lifeless wasteland. Sirkka-Liisa Konttinen's *Coal Coast* depicts the vibrant material transformations and landscapes created. Instead of a dead landscape of toxins, there is the awful and awfully lively world of chemical and physical transformations. As she wrote, by visiting a stretch of Durham coast she began to:

> "...see narratives in this blighted landscape. The glistening black sands of fools' gold, purple rocks of burnt shale, pebbles glowing with iron sulphate. Embedded in fused colliery spoil, among the emerald green seaweed, the nuts and bolts of a deposed industry are rusting into riotous colour. A lone segment of a ventilation duct crouches on the beach like an exotic seashell, while a miner's boot quietly disintegrates in the clay. The landscape is most eloquent in its post-industrial silence. As in a shop window at Seaham figurines of miners, pressed from coal dust, commemorate a lost world, so do these dislocated relics on the beach..." (2000)

So here is a landscape of terrible beauty, unruly and unclean. Far from being dead places, she finds, "...miners' boots, swimming in fluorescent chemical ponds [where] they appear animate, expressive, even urgent." The afterlife of industry appears in pictures that show metal bolts and detritus fusing into new anthropogenic conglomerates of rock at Dawdon, along from startlingly coloured pools and stained

rocks at Hawthorn Hive. On the opposite coast of the country and some eight years later, Jem Southam walked the Cumbrian coast, which he found similarly composed of anthropogenic formations (Southam 2008). One of his companions, Richard Hamblyn, speaks of "Workington's metalline foreshore" that betrays the legacy of the 130 years of activity at the Moss Bay steel works whose last elements closed in 2006. Their walk becomes "...a two-hour scramble over what looked at first like limestone pavement but turned out to be a mixture of heat-fractured metal, iron slag, and quartzite pebble distributed unevenly underfoot." (Hamblyn 2008).

The collision of memory and monument is more widely figured through the abandonment of objects – where the line between an archaeological site and a dump becomes very unclear. Thus in Ryd, in Småland in Southern Sweden, an isolated hermit, Åke Danielsson, made a scant living from the 1950s to the 1990s repairing cars at his lonely, self-built hut in the forest. Upon his retirement, he left behind a scrap yard of old vehicles sinking into the forest moss. The discovery of this led to conflicting responses from the local environmental and heritage authorities, one of which saw a dump and the other a remarkable relic of consumer life and repair (Burström 2009). Perhaps unsurprisingly, the heritage authorities saw this as an unruly eyesore that did not fit the histories of the area, while the environmental authorities were struck by the elegiac invocation it offered of cars and lives fondly remembered by a generation of Swedes. Across the world, Pablo Cabado's (2012) *37°57'35"S 57°34'47"W* project documents a derelict amusement park some 300 miles from Buenos Aires, to reveal the livelihoods still being scraped together amid the collapsed rides and faded decorations of an entertainment complex abandoned 10 years earlier. Here the affective charge is that of entertainment set against both dereliction and the struggle for livelihoods. A similar charge is mobilised in Pawlikowski's film *Welcome to Dreamland* where a mother and child who come to Britain to follow a romance, find the supposed fiancée is missing and become accidental asylum seekers as the only way to enter the country. But upon so doing, they become trapped – debarred from working, left skirting the edge of criminality and the sex industry to make a living, they are housed in a grim seaside town opposite the closed funfair called Dreamland (Bardan 2008). This is a world in limbo between place and time. In some ways, the framing is an any-time-wherever, and yet it is a place haunted by pasts that cannot be left and futures foreclosed. Capturing that sense of temporal flow suspended, or time out of joint, seems crucial in the way this picturing of post-industrial places or 'ruins in the becoming' works. It leaves the possibility, not only of stasis – of being stuck in the past – but of desynchronised times. Past times do not fade but also continue, and even evolve in different paths.

Such uncomfortable moments of anachronism do not fit the imagination of English heritage that is written through a pastoral idiom. The landscape of gentle countryside has perhaps been broadened to include an industrial pastoral of manufacturing heritage now quiescent in natural surroundings, where industrial museums are shorn of the life and terror possessed by industries when they were new and dominant. Such a pastoral may include the elegiac but is much more comfortable with the renovated. Here the coal coast has been cleaned with the removal of 1.5 million tons of debris, and is only now designated a 'Heritage Coast', winning the Council of Europe Landscape prize. Konttinen's photography came through many rambles that ended she says at the allotments at Easington colliery, where retired miners grew vegetables and flowers and had their pigeon lofts. This was the unruly human side of the mining world John Davies also pictured, with a shot from the allotments, all fronted by recycled doors in a makeshift fence, leaving just the roofs of houses hazily visible in the misty sea air. But Konttinen's work ends with pictures of allotments that had been cultivated for up to 80 years being razed and bulldozed to make way for that cleaned upheritage. As she acidly observes, "The future lay with tourism. The manifestly idiosyncratic allotment gardens simply did not fit into the planners' vision of the new era." (Konttinen 2000). When John Davies revisited his photographic sites and the site of Easington colliery in 2004, he found the previous world had vanished. Where he had previously composed a shot with the pithead rising behind the roof tops, where it stood between those rectilinear rows of houses and the sea, now the site of the colliery he pictured is a wide open expanse of grass which ends at the cliff tops leaving the equally uninterrupted expanse of the sea running to the vanishing point on the horizon (Davies 2006).

This cleansing is not untypical. For instance, South Tyneside once had four large collieries that directly employed 12,000 at their peak in the 1920s, and still employed 2000 when mining ended in the 1990s. Now there is more visual evidence there of Roman habitation than of that mining history (Byrne and Doyle 2004). The very photography of the end of that tradition by Davies, in his beautiful black and white shots, seems to confirm it as a past period. Many young people in the region associate the 'time of coal' as the past, and moreover as a dirty and derelict past that is best left behind (Byrne and Doyle 2004).

HORIZONS OF EXPECTATION ON THE GEORDIE SHORE

Elegiac pictures of a disappearing world have been a standard trope of depicting the British landscape for more than two centuries. Oliver Goldsmith's poem *The Deserted Village* bemoans the destruction of worlds of rural life with agricultural modernisation and enclosure. As "Amidst thy tangling walks and ruin'd grounds" he strolls and the stream all "chok'd with sedges, works its weedy way" and the "long grass o'ertops the mould'ring wall", he found shapeless ruin as an indictment of the rise of commercial interest destroying a rural moral economy. A hundred years later, at the end of the nineteenth century, the landscape painting of Philip Wilson Steer depicts a fading rurality which he accentuates by depopulating the scene to show decay and decline (Holt 1996) in places seemingly abandoned and empty. At the start of the twentieth century, George Clausen's rural paintings focused on the category of the 'peasant', lingering on gleaners returning from the field or a 'peasant girl carrying a jar' to record landscapes and ways of life that were already fading (Robins 2002). It is easy and still salutary then, to remind ourselves that this was the world that Goldsmith had mourned as already dead 150 years earlier. As Raymond Williams (1973) noted, rural nostalgia seems like an endlessly receding elevator where authentic rural life is always one generation and half a century earlier. This pastoral says less about the life of the country than the perennially painful pleasure of nostalgia. Thus when Clausen exhibited his painting *Haying* in 1882, where two young women are seemingly effortlessly turning forkfuls of grass next to the rumpled blanket on which are the remains of their picnic lunch, the public swooned at this rural idyll – no matter that in the area he was depicting haymaking was a massively skilled, almost entirely male

task marked out by a period of fighting and heavy drinking. The same year his *Winter Work,* with bleak wintry tones and male and female workers bent over, labouring in the viscous mud, instead echoed fears about women workers and was dismissed in *The Times* as "...really too ugly..." (Robins 2002:13, 18). The emptied, idealised landscape of a lost rural England has come to exemplify both "moral order and aesthetic harmony" (Daniels 1993:5).

The post-industrial pastoral can sit in this frame of lost heritage. The 'lost world' can be beautified and packaged as safely historic. Industry becomes something to be transcended. Thus the massive and wonderful endeavour, Beamish: the Living Museum of the North, collects fragments of the industrial past from across the region and reassembles them in an open-air setting. There is the street of tiny miners' cottages, the Co-operative grocery, sweet shop and dentist all accurately and carefully reconstructed. There is even the only remaining underground mine in the North East into which visitors can descend. But here the choice is 'old coal' of an ancient drift mine rather than 'new coal' of the modernised superpits. The museum presents life in 1913 – the peak of coal output, and just fading from living memory. In the terms of the French historian Pierre Nora (1997), it is thus a move from *milieux de mémoire* (worlds of memory), to a consciously cultivated *lieux de mémoire* (places of memory). That is, these traditions need to be preserved precisely because they are no longer part of our current worlds.

The depiction of this post-industrial world seems too neatly severed from the present. There is more of a persisting presence for people who are not now former miners but the children and grandchildren of former miners, still living in places struggling to escape being, or most certainly being only, former pit villages. David Severn's exploration of the Nottinghamshire coalfield *After Maggie* thus also finds natural life among sapling silver birch, but then goes foraging for fungi on the wood stock yard at the Pleasley Pit Nature Reserve with the Pleasley Pit Nature Study Group. His photos mix a world of new nature reserves and walking paths, with young women waiting in the empty colliery site for friends, young men out rabbiting for food and fun with the counterculture performers of the Headstock Festival taking place

John Kippin
CAR PARK POLICE, 1992/2012
Inkjet pigment print on paper 40 x 32"

on the former Newstead Colliery. This is a world of the contraction of the present (Lübbe 2009) if we call the present a 'space of experience' that is linked to the still-relevant past that is continuously shrinking, while the 'horizon of expectation' calls on an unknown, ever-expanding future (Barndt 2010). The old is dying and provides less of relevance to guide our futures, yet cannot be forgotten.

Pictures to capture such temporal complexity need to offer more than simply mournful ruins to a world that is lost. They need to speak of a landscape that is a palimpsest that still bears 'traces and redundancies, obsolences and irrationalities' that are both the burden of the past and an inheritance (Crang 1996:430). John Davies' photography of Northern cities may have started in a period of deep decline but his recent *Metropoli* project continues his observations. His *British Landscape* project offered black and white vistas such as Netherthorpe in Sheffield with great slabs of concrete 'dwelling units' cutting through the city, or the strangely futuristic yet now dated cubic houses in Kenton in Newcastle upon Tyne. Early this century, his colour pictures portray reclaimed heritage and renovated Victorian buildings amidst which erupt shining new developments of shops, offices and hotels, often set about some hopeful public space. In such sites we see how:

> "The archaeological layers of past Victorian grandeur found new functionalities within the service economy. Signs of the post-industrial regeneration process multiplied as cities endeavoured to reconstruct their images and identities." (Gee 2010:329)

The landscape is a juxtaposition of asynchronous moments where space forms a container for different eras rather than showing time as a linear process (Crang and Travlou 2001:161). Time does not simply flow, but it rather eddies and swirls. Or, to use a different metaphor, landscapes are made through crossing elements, folding one time into another, and with past and future piercing the present. There is not some sedimentary layering of elements, but rather a jumping from one epoch forward to another and then back again to a preceding one.

These are pictures where the glitz and glamour of the post-industrial consumption spaces abut the tail end of industrialism. John Kippin's

Metrocentre Xmas is a shot back from the mall across a crammed car park to the West End and the Elswick arms factory. A factory that once formed the cornerstone of imperial armaments for the local industrial tycoon Lord Armstrong, became the Vickers tank factory and is now being wound up, nestles below the streets of the West End that have since been undergoing another round of demolition in the name of regeneration. A new statue of a miner leading a pony forwards ridden by two children is part of the renewal efforts. Ostensibly it commemorates the 38 miners who were killed in the Montagu View Pit Disaster, but it has already been claimed to also speak for the threatened factory. Officially entitled *Yesterday, Today, Forever*, it is meant to speak of community continuity, building on traditions, yet it highlights the partiality of such stories of continuity, since to focus on the industrial legacy of the North East is a simplified history.

Newcastle also has a long history as a centre of consumption. Celia Fiennes remarked of Newcastle in 1698 that, "...their shops are good and are of distinct trades, not selling many things in one shop as is the custom in most country towns and cittys." (cited in Glennie and Thrift 1996:32). The first department store outside London was Fenwick, and the Georgian redevelopment of Newcastle by Richard Grainger ripped out the mediaeval city to create an orderly and profitable space of consumption. Grey Street, sweeping down to the river from the eponymous statesman atop his pillar, was voted Britain's best street on a BBC Radio 4 poll, and also cost rather more than the Strand to build. The abutting of different histories and futures can be found in the vista that for years was framed from the foot of the monument – the Owen Luder designed car park known ubiquitously for its role in the movie as the '*Get Carter* car park' – that in turn has now been demolished to make way for a Tesco. Yet such a monument and its fate seem fitting for a landscape that J.B. Priestley described in his *English Journey* (1934) thus:

> "There seemed a great deal of Gateshead and the whole town appeared to have been planned by an enemy of the human race in its more exuberant aspects. Insects can do better than this: their habitations are equally monotonous but far more efficiently constructed. As the various industries of Gateshead

John Kippin
REGENERATION 2008/2012, diptych
Inkjet pigment print on paper 50 x 20"

are in a state of rapid decline, it is possible that very soon it will be in the position of the decayed medieval towns, those ports that the sea has left, but unlike those medieval towns, it will not, I think, be often visited by tourists in search of the quaint and the picturesque. Ye Olde Gateshead Tea Rooms, I feel, will not do a brisk trade. The town was built to work in and to sleep in. You can still sleep in it, I suppose."

What would Priestley have made of the Baltic Flour Mill's dereliction then rise again as a prize-winning gallery, or Team Valley colliery pit baths becoming the site of Antony Gormley's *Angel of the North*? The size of a jumbo jet, its rusting steel represents the heritage of the area in abstract form. If angels were messengers, then what message does it convey? For many other cities in the North, it conveyed a simple message of one-upmanship. Its opening was followed by a wave of municipal 'angel envy' across other local authorities. For locals, it has been adopted as an icon – as became clear when it was clad in the Newcastle football strip for the cup final. It is not clear whether such adoption will follow for the monumental sculpted earth art figure Charles Jencks is creating at Shotton surface mine near Cramlington, with 1.5 million tons of slag and debris to sculpt the largest human form in the world. Named *Northumberlandia*, the hope is this reclining female 'Goddess of the North' will aesthetically connect land and people, have the same iconic effect as the Angel, being some 400 metres in length with breasts rising 34 metres high, and become adopted by locals – rather than keep the epithet of 'Sleeping Slag Alice' given by local opponents.

It is all a long way from natural scrub reclaiming slag heaps in John Kippin's *After Coal*. The fabricated invention of pseudo-mythic pasts though has a local tradition. Standing on a hill above Herrington Colliery, and now country park, is Penshaw Monument, a half-sized replica of the ancient Temple of Hephaestus (god of fire and metallurgy) in Athens. It was built in 1844, to celebrate 'radical Jack' Lambton, first Earl of Durham on the hill itself made famous by the legend that it was made by the coils of the Lambton Worm. Its 20-metre tall gritstone columns remain one of the few structures uncleaned from soot and industrial grime.

It remains a necessary angle of any vision to see that cleaning the coal coast and the resuscitation of the Tyne and Wear rivers are widely and rightly celebrated as environmental benefits. And yet, the region remains saturated with the products of industry – from the steel and glass of the waterfront regeneration, to the iPods and iPads of teenage desires. The production has been moved and with it, the waste and dirt and mess. As the Tyne has been cleaned, rivers in China and South Asia have been poisoned. Rather than simply erasure or nostalgic celebration then maybe the power of some images is as, what Walter Benjamin called, "dialectical images", in which the old fashioned or undesirable suddenly appeared current, or the new, desired suddenly appeared as a repetition of the same (Buck-Morss 1986:100). Surprising juxtapositions disrupt the coherence of pastoral heritage scenes, revealing what they exclude. In Kippin's *Hidden* the wreckage of a fighter appears out of place in the Northumbria national park. His picture of an Asian prayer meeting at Windermere raises again the questions posed by Ingrid Pollard's Pastoral Interlude series where she captioned self-portaits of herself in the Lake District "…it's as if the black experience is only lived within an urban environment. I thought I liked the LAKE DISTRICT, where I wandered lonely as a Black face in a sea of white. A visit to the countryside is always accompanied by a feeling of unease, dread".

It is this world of temporal and spatial confusion where John Kippin can picture a cold war pastoral. His study of Greenham Common challenges notions of permanence and importance by treating the remains of a protester's tepee, the same as he does the massive cruise missile launchers' bunkers. Bunkers and control systems that once spoke of a future foreclosed by nuclear Armageddon now become sites of nature and mystery. The National Trust now offer tours of the nuclear testing site at Orford Ness leading the visitor, amidst reeds and wildlife, to the deserted Pagodas – the local name for testing structures designed to absorb blasts. In this strange landscape the viewer can come to appreciate 'order in disorder and the beauty in ugliness' as they survey the most extreme human technologies set in a site now given over to nature (Wainwright cited in Davis 2008:143). The tension is to preserve the ragged and unruly connections in space and time that form the landscape, rather than smooth them away. Dominant stories

tend to focus on heavy industrial production. They leave untold the stories of the wastes and by-products. They leave untold the long histories of service industries and consumption. They leave untold the distant markets for all those coal steel and ships, on which the jobs depended. They leave unanticipated the returns from those places that now make up the region. To celebrate the complex histories and identities of the region – that is the challenge for and from skilful landscape photography.

REFERENCES

Austin, D. and S. Doerr (2010). *Lost Detroit: Stories behind the motor city's majestic ruins*. Charleston, SC: The History Press

Bardan, A. (2008). 'Welcome to Dreamland: The realist impulse in Pawel Pawlikowski's Last Resort.' *New Cinemas: Journal of Contemporary Film* 6 (1): pp.47-63

Barndt, K. (2010). 'Layers of Time: Industrial Ruins and Exhibitionary Temporalities.' *PMLA* 125(1): pp.134-141

Brady, E. (2010). 'The Sublime, Ugliness and "Terrible Beauty" in Icelandic Landscapes'. *Conversations with Landscape*. K. Benediktsson and K.A. Lund. Farnham: Ashgate: pp.125-136

Buck-Morss, S. (1986). 'The Flâneur, the Sandwichman and the Whore: The Politics of Loitering.' *New German Critique* 39: pp.99-139

Burström, M. (2009). Garbage or Heritage: The Existential Dimension of a Car Cemetery. *Contemporary Archaeologies: Excavating Now*. C. Holtorf and A. Piccini. Frankfurt, Peter Lang: pp131-144

Byrne, D. and A. Doyle (2004). 'The visual & the verbal: the interaction of images and discussion in exploring cultural change'. *Picturing the Social Landscape : Visual Methods in the Sociological Imagination*. C. Knowles and P. Sweetman. London, Routledge: pp.166-177

Cabado, P. (2012). *37'57'35s 57'34'49w*. Buenos Aires: La Marca Editora

Crang, M. (1996). 'Envisioning Urban Histories: Bristol as palimpsest, postcards, and snapshots.' *Environment & Planning A* 28(3): pp.429-452

Crang, M. and S. E. Travlou (2001). 'The City and Topologies of Memory.' *Environment & Planning D: Society and Space* 19(2): pp.161-177

Daniels, S. (1993). *Fields of Vision: Landscape Imagery & National Identity in England and the US*. Cambridge: Polity Press

Davies, J. (2006). *The British Landscape*. London: Chris Boot

Davis, S. (2008). 'Military landscapes and secret science: the case of Orford Ness.' *Cultural Geographies* 15(1): pp.143-149

Diehl, C. (2006). 'The Toxic Sublime.' *Art in America* 94(2): pp.118-123

Garn, A. (1999). *Bethlehem Steel*. New York: Princeton Architectural Press

Gee, G. N. (2010). 'The Representation of the Northern City in the Photography of John Davies (1981–2003).' *Visual Culture in Britain* 11(3): pp.329-339

Glennie, P.D. and N.J. Thrift (1996). 'Consumers, identities, and consumption spaces in early-modern England.' *Environment and Planning A* 28(1): pp.25-45

Gramsci, A. (1971). *The Prison Notebooks*. London: New Left Books

Hamblyn, R. (2008). 'Metal beach'. *Clouds Descending*. J. Southam. Salford: Lowry Press: pp.95-111

Higgins, J.J. (1999). *Images of the Rust Belt*. Kent: Kent State University Press

Holt, Y. (1996). 'Nature and Nostalgia: Philip Wilson Steer and Edwardian Landscapes.' *Oxford Art Journal* 19(2): pp.28-45

Holt, Y. (2010). 'Introduction.' *Visual Culture in Britain* 11(3): pp.323-327

Jorian, T. (2010). *Ilôts Intemporels - Timeless Islands*. Paris: Thomas Jorion.

Konttinen, S.-L. (2000). *Writing in the sand : on the beaches of north east England* Stockport: Dewi Lewis

Lübbe, H. (2009). 'The Contraction of the Present'. *High-Speed Society: Social Acceleration, Power and Modernity*. H. Rosa and W. Scheuerman. Philadelphia: Penn State University Press: pp.159-178

Marchand, Y. and R. Meffre (2010). *The Ruins of Detroit.* London: Thames & Hudson

Maskit, J. (2007). 'Line of Wreckage: Towards a Postindustrial Environmental Aesthetics'. *Ethics, Place & Environment* 10(3): pp323 -337

Moore, A. (2010). *Detroit disassembled* Akron Ohio: Akron Art Museum.

Nora, P., Ed. (1997). *Realms of Memory: The Construction of the French Past (2) Traditions.* New York: Columbia University Press.

Plowden, D. (2006). *A Handful of Dust: Photographs of Disappearing America.* New York: W. W. Norton and Company

Richardson, C. (2010). 'Contemporary Scottish Art and the Landscape of Abandonment.' *Visual Culture in Britain* 11(3): pp.391-405

Roberts, I. (2007). 'Collective Representations, Divided Memory and Patterns of Paradox: Mining and Shipbuilding.' *Sociological Research Online* 12(6):6

Robins, A. G. (2002). 'Living the Simple Life: George Clausen at Childwick Green, St. Albans.' *The Geographies of Englishness: Landscape and the National Past 1880-1940.* D. Corbett, Y. Holt and F. Russell. New Haven: Yale University Press: pp.1-28

Skrdla, H. (2006). *Ghostly Ruins: America's Forgotten Architecture,* New York: Princeton Architectural Press

Smithson, R. (1996). *The Collected Writings.* Berkely: University of California Press

Solnit, R. (2007). 'Detroit arcadia: Exploring the post-American landscape.' *Harper's Magazine*: pp.65-73

Southam, J., Ed. (2008). *Clouds Descending.* Salford: Lowry Press.

Williams, R. (1973). *The Country and the City.* London: Chatto & Windus

John Kippin
AMERICAN COAL, 2011/2012
Inkjet pigment print on paper 40 x 32"

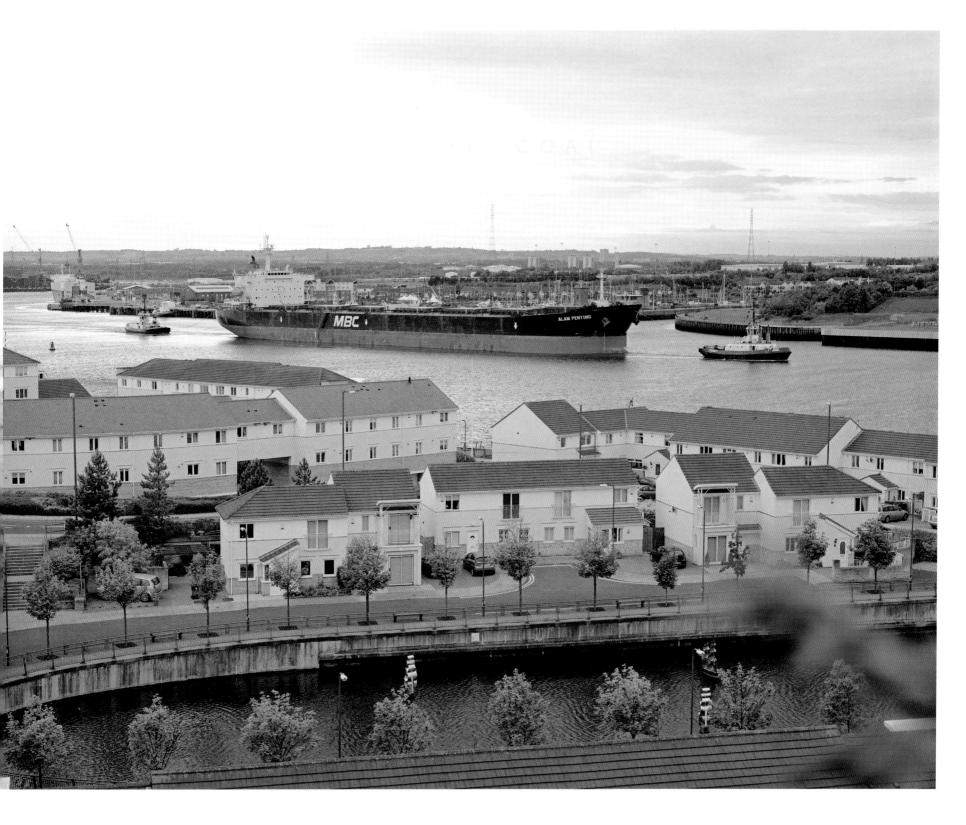

John Kippin
HARBOUR VIEW, 2012/2012
Inkjet pigment print on paper 40 x 32"

>
THE IMPROBABILITY OF VIRTUE, 1990 /2012
Inkjet pigment print on paper 72 x 30"
(installation with gents sports bicycle)

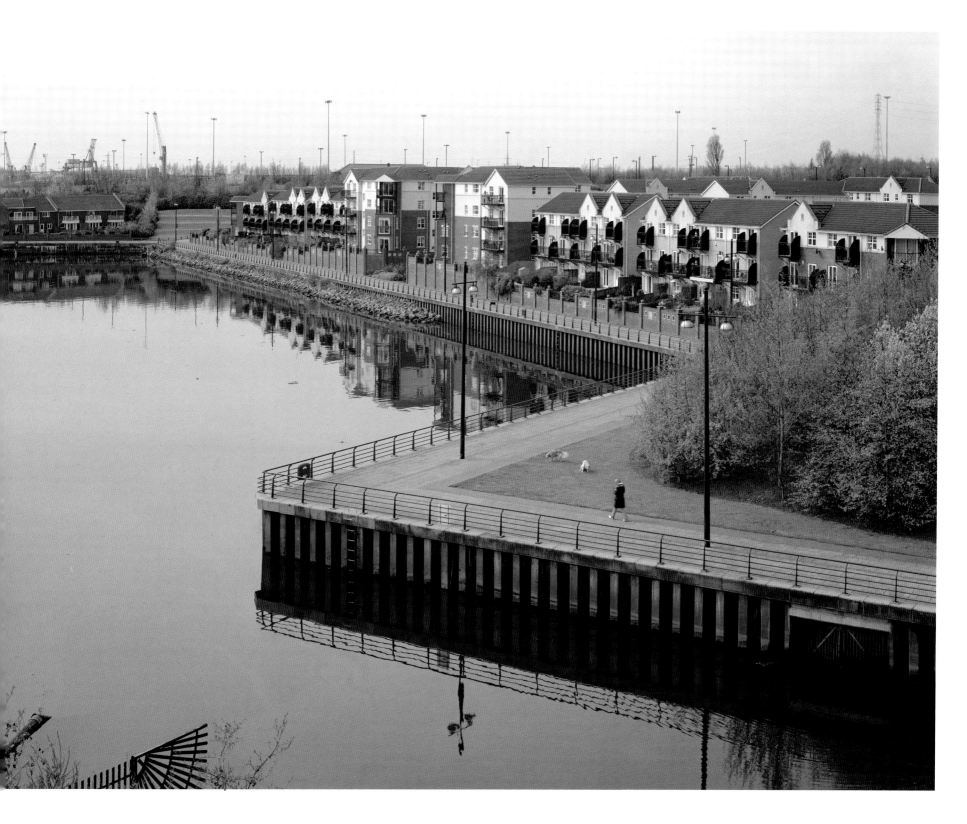

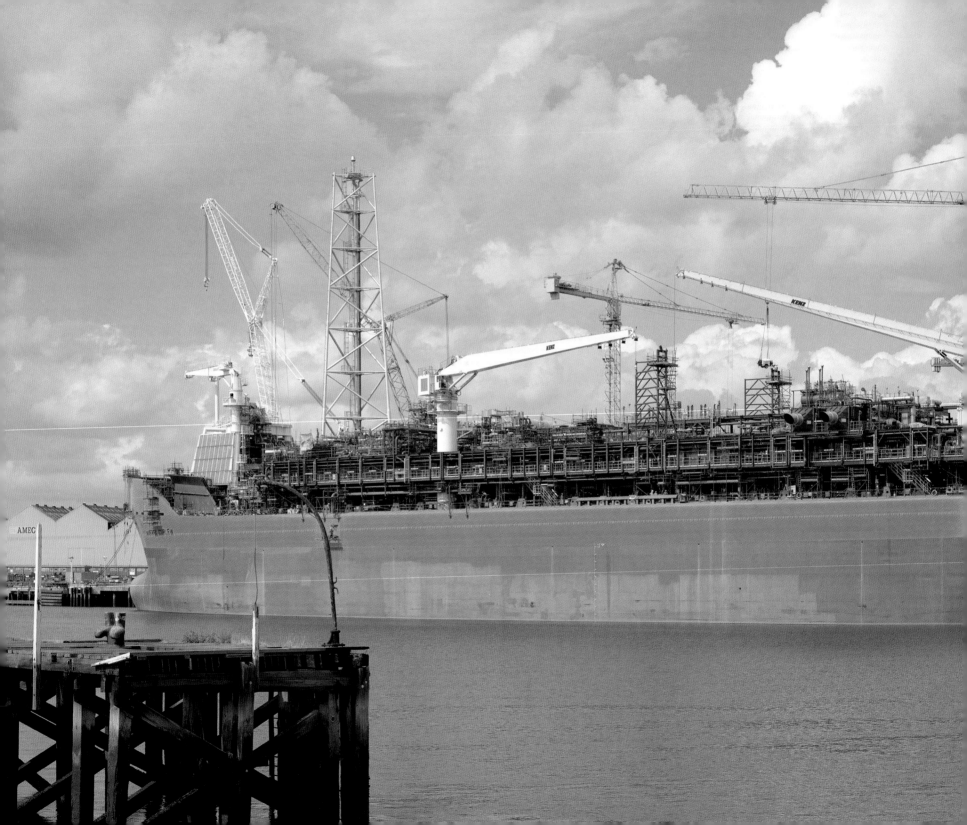

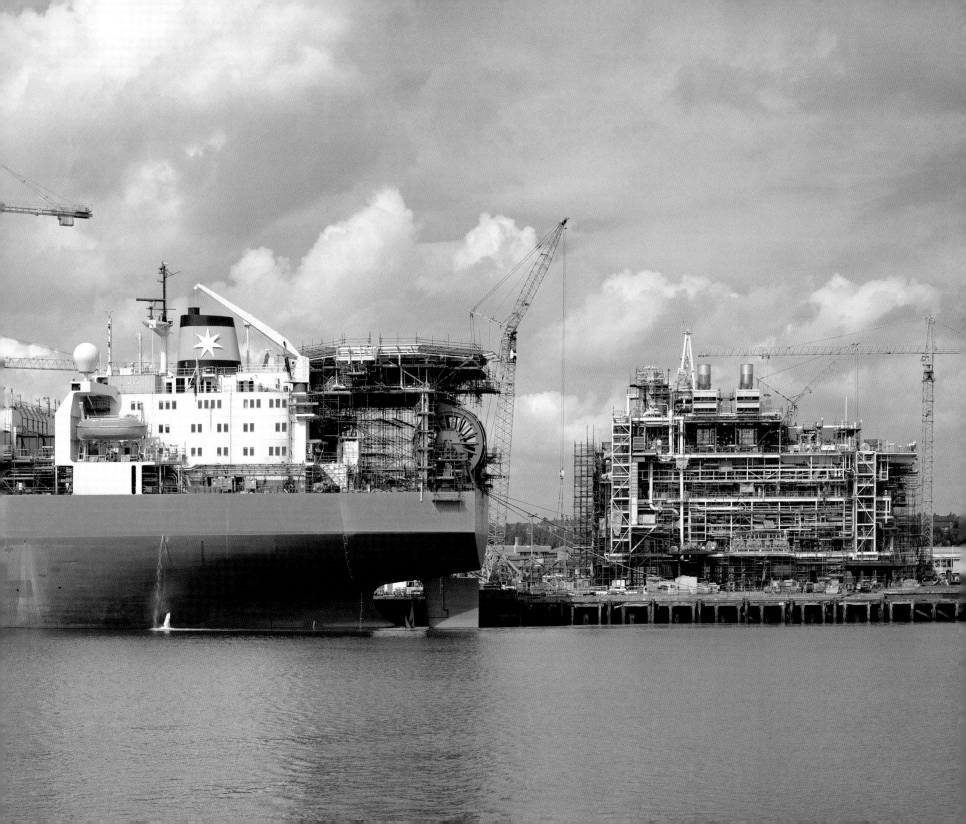

John Kippin
Stills from *ARC*, 11 min HD Video projection, 2011
(The *Ark Royal* on its final farewell to the Tyne, where it was built.)

John Kippin
BENEATH, 2010/2012
Inkjet pigment print on paper 40 x 32"

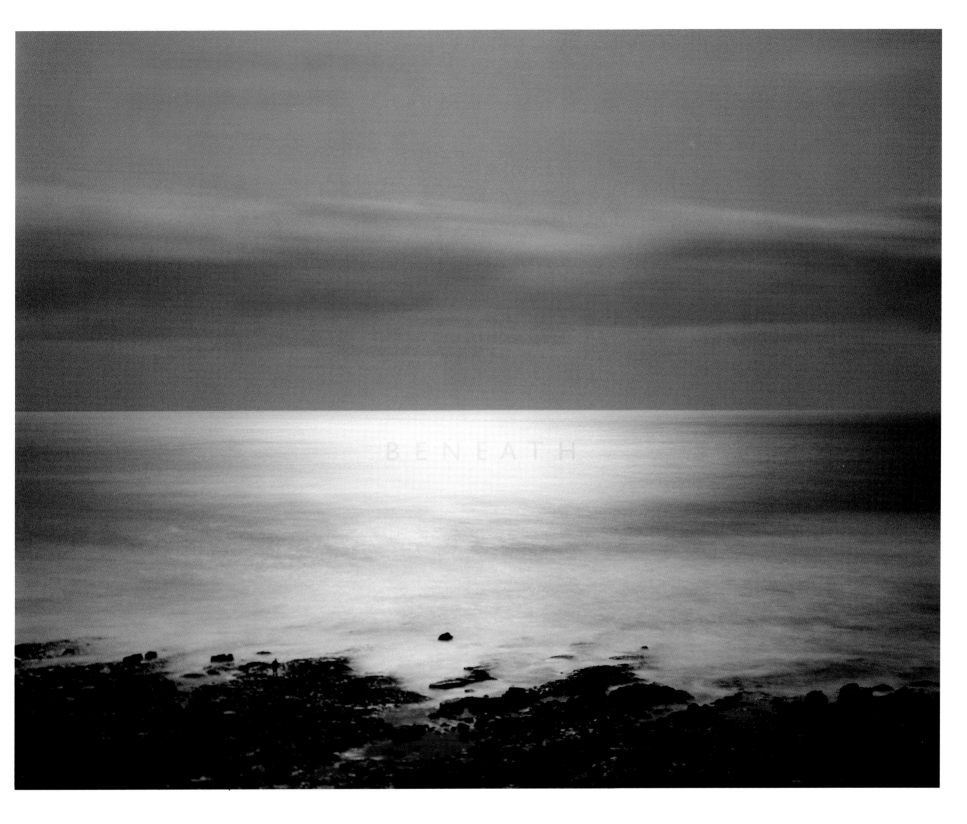

Chris Wainwright
Semaphore Alphabet 1 Solstrand, Norway
Inkjet print on paper, 2009

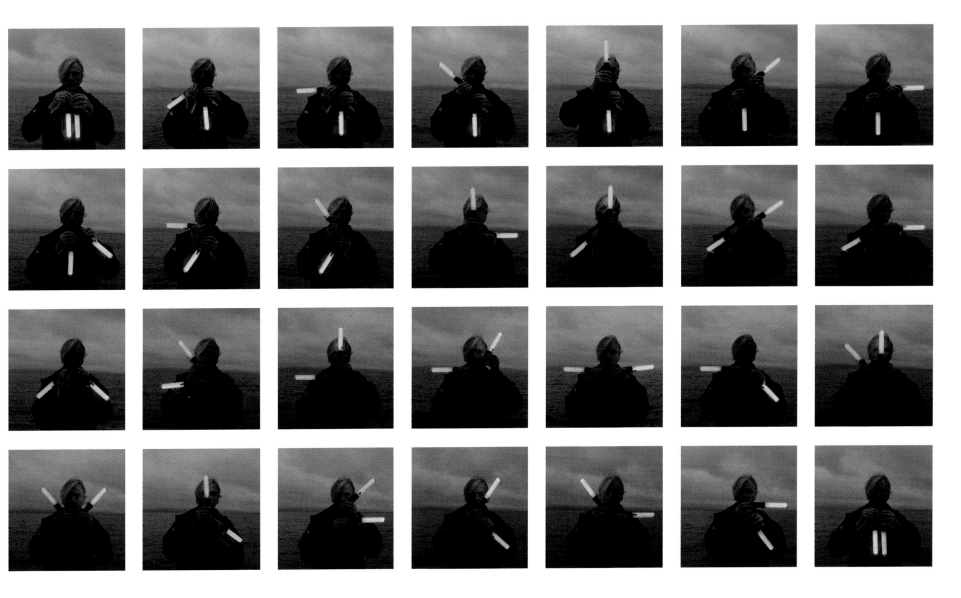

Chris Wainwright and David Bickerstaff
Channel 14 Video, 5 mins
2004

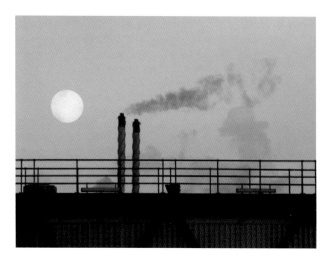

 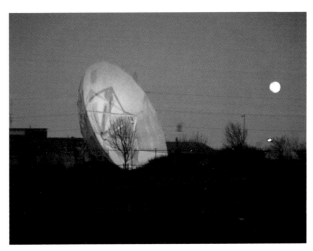

Chris Wainwright
Sold Down the River Wearside
Inkjet prints on paper, 2012

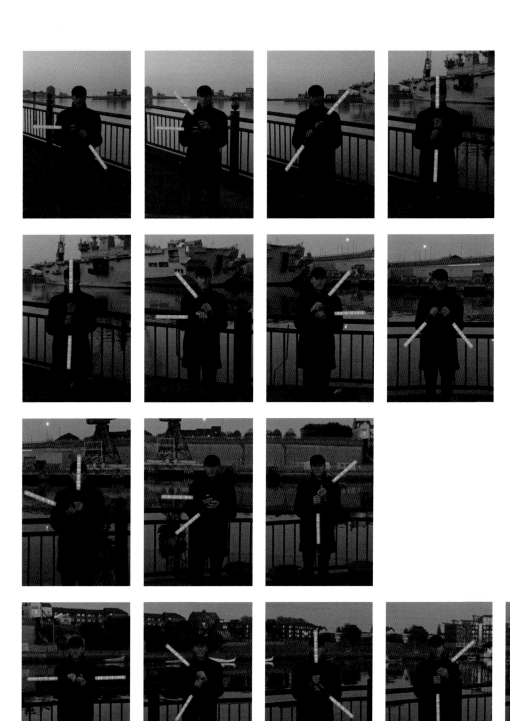

Chris Wainwright
Error Teesmouth, UK
Inkjet print on paper, 2012

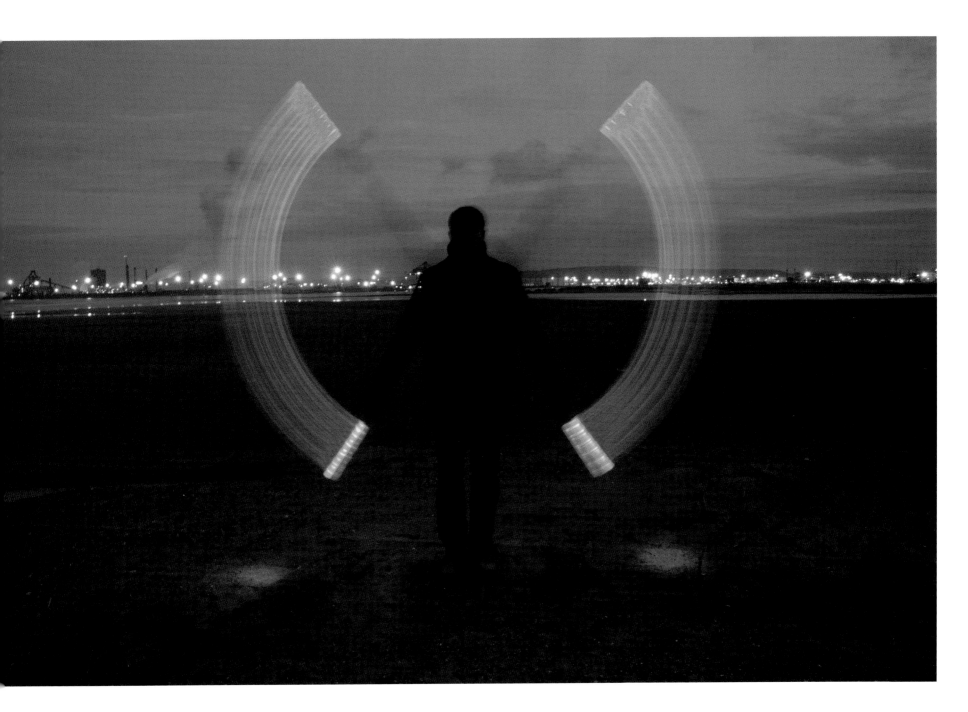

Chris Wainwright
Error Sunderland, UK
Inkjet print on paper, 2012

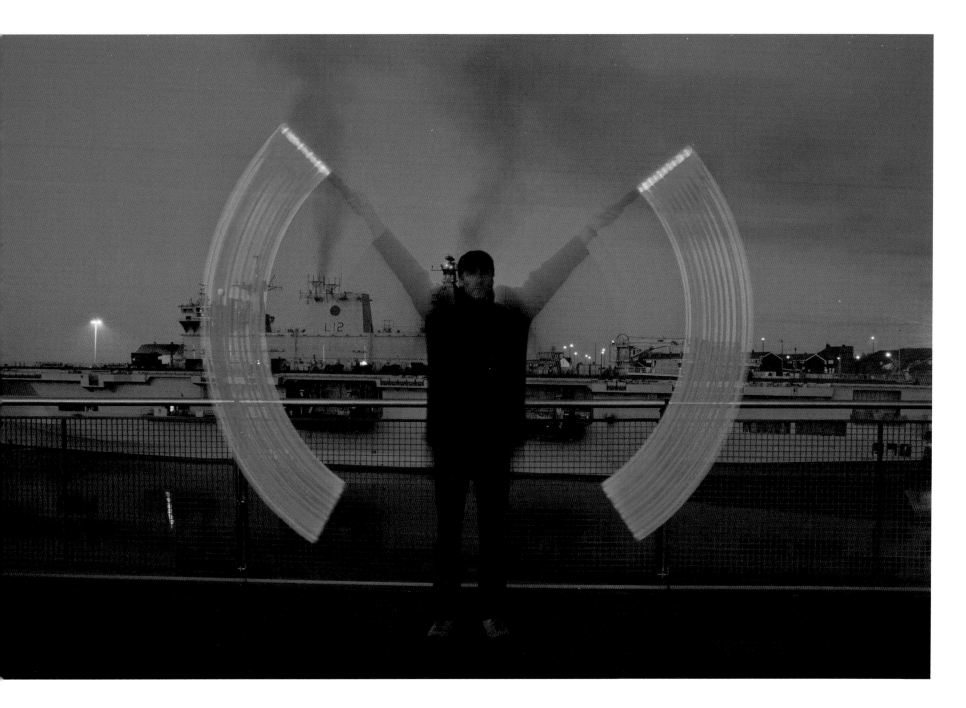

Chris Wainwright
Error Blyth, UK
Inkjet print on paper, 2012

>
Chris Wainwright
The Great Day of His Wrath (after John Martin)
Teesmouth, UK
Inkjet prints on paper, 2012

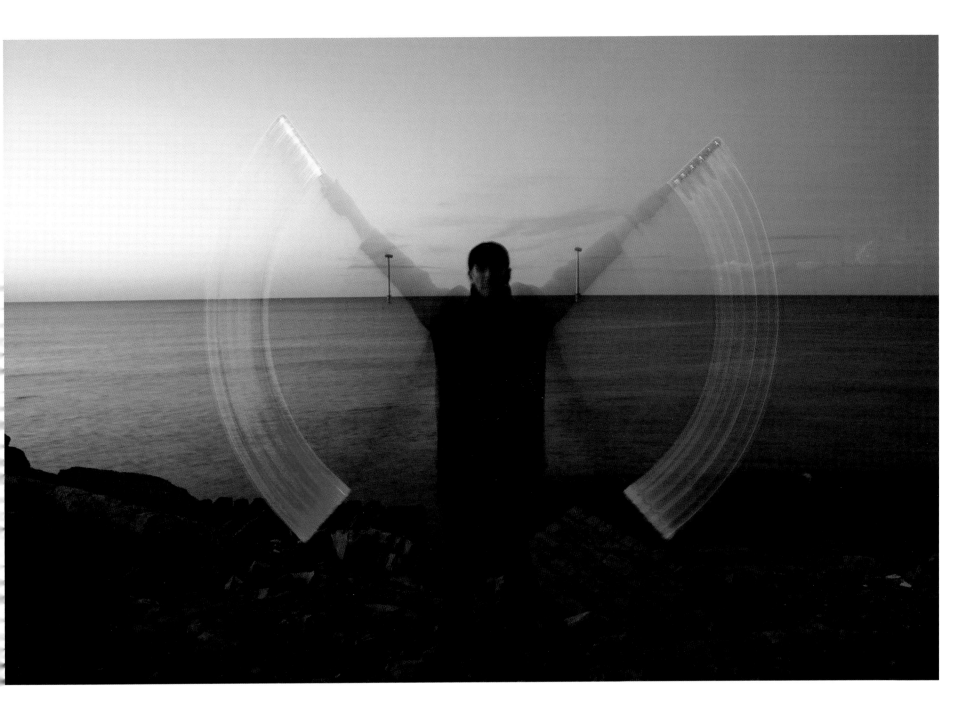

John Kippin
WHEN THE BOAT COMES IN, 2010/2012
48-sheet billboard poster

當船來

WHEN THE BOAT COMES IN

John Kippin
ADAGIO, 2009/2012, tryptich
Inkjet pigment prints on paper 75 x 20"

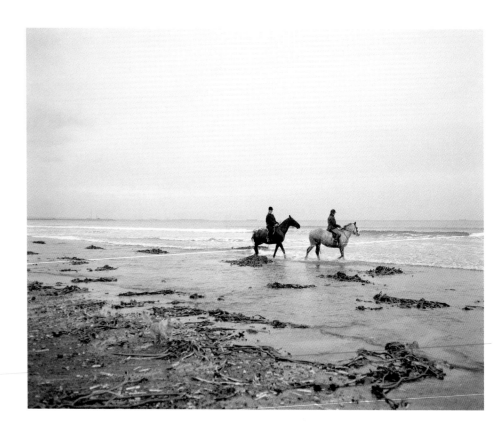

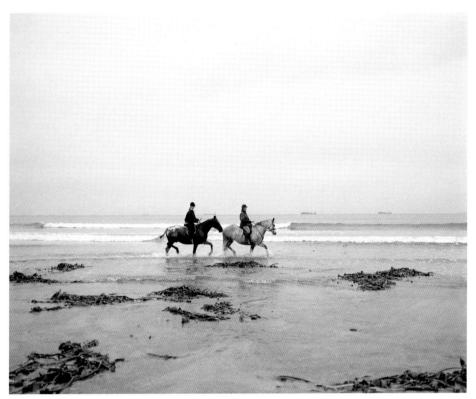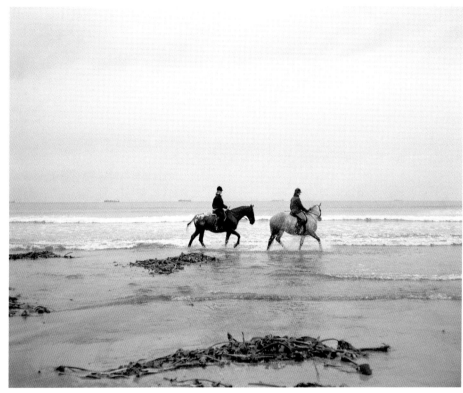

BLAST FURNACE

John Kippin
BLAST FURNACE, 2011/2012, tryptich
Inkjet pigment prints on paper 75 x 20"

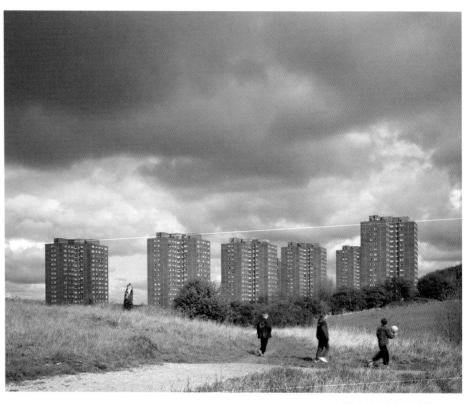

THE SECRET

 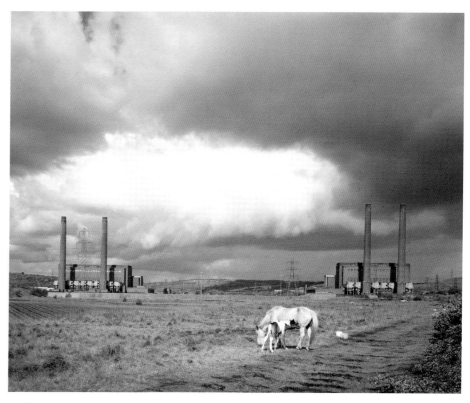

INTELLIGENCE OF THE SILENT

John Kippin
THE SECRET INTELLIGENCE OF THE SILENT, 1996/2012, tryptich
Inkjet pigment prints on paper 75 x 20"

John Kippin
SCRAP METAL, 2009/12
Inkjet pigment print on paper 40 x 32"

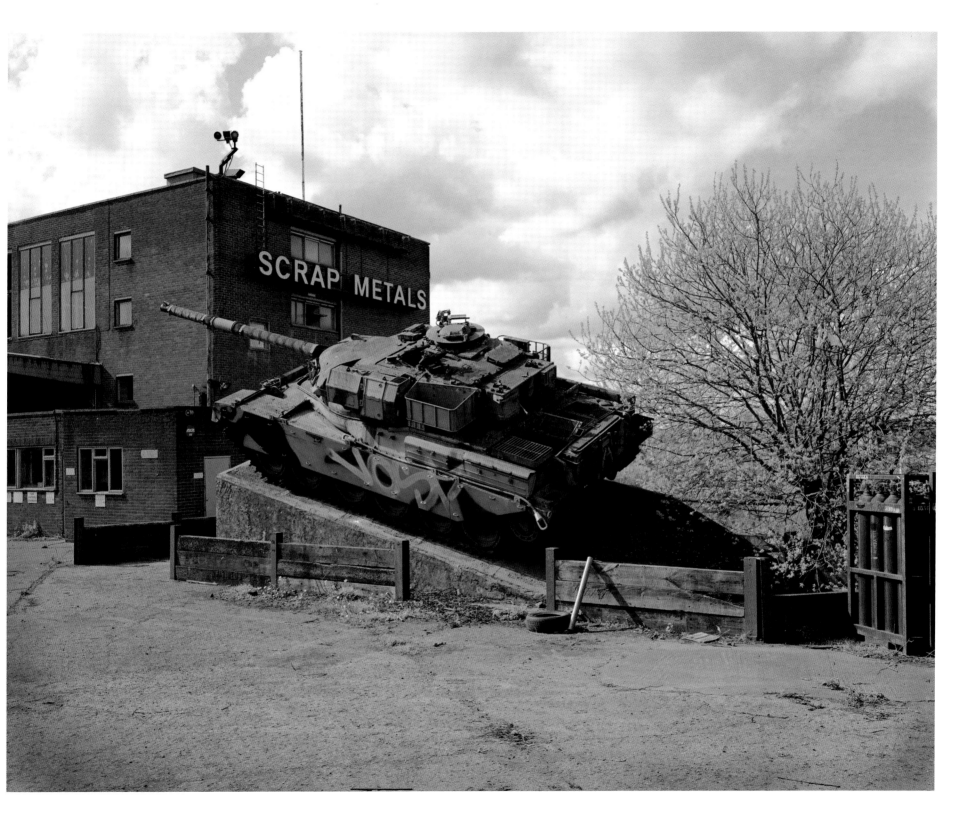

John Kippin
LISTEN, 2012, stereographic images
Inkjet pigment prints on paper 40 x 20"

FUTURELAND NOW

John Kippin and Chris Wainwright
in conversation with **Liz Wells**
London 2012

In the run up to *Futureland Now*, the two artists met with Liz Wells, editor/curator, to reflect upon some of the issues raised through their work. This included: the role of art, in terms of social investigation and commentary, the North, as concept related to a changing industrial and mercantile social economy; aesthetic strategies, radicalism and hegemonic processes within visual language; the limits of documentary. The conversation also explored how the two artists came to work together in the first place, the sociopolitical context within which that initial working relationship developed and why it seems important now to revisit questions interrogated though the original exhibition and publication *Futureland* (1989). Noting that the focus or fulcrum of the project is the North East of England, they reflect on visual practice as a means of addressing the global nature of economic links and social resonance.

LW | John what is your immediate reaction to the role of art if we are thinking about its social investigation, about art as commentary on contemporary issues?

JK | It is such a difficult question, because I think that probably most artists feel their expectations of what they do running way behind the practical reality that they can reasonably expect to achieve in terms of changing anything. So, to me, the process of art acts as more like water eroding a stone rather than something that is hugely incisive or active. But, if we're involved in it, it culturally positions us in a place where there is some possibility to think about values. And if art doesn't become an embodiment of values then it really doesn't have much purpose.

CW | Yes, I broadly agree with that. I think there is an issue about the role of art but there is also a question about the position of artists. Over a period of time the artwork and artists grow further apart for obvious reasons – art generally lasts longer than people. So art does have an initial close functioning relation to the artist, to authorship and its dissemination, but also, over time, art acquires a progressive independence from the artist, and therefore its intentionality and reception can shift significantly. In some ways that condition of independence or distance was part of my interest in revisiting *Futureland* almost 25 years from the first time that we engaged with the idea of creating it. The work we produced back then, now has a detachment from ourselves in the sense that it was

Chris Wainwright
Entrance to the Forbidden City Beijing, China
C Type print on aluminium, 2010

produced at a time when we were probably thinking very differently to the way we think and work now. In a broader sense, for me it was not about making the work address social issues because I am not sure by choosing to be an artist you can really say that you are embarking on a strategy that's likely to bring about significant changes in those issues by your individual actions; you'd choose another profession if that was the case. But I think artists do have a responsibility to be a concerned witness, to be engaged critically with issues that then come out through their work. The work shouldn't necessarily illustrate social issues or concerns, but recognise that they significantly inform it; sometimes in a very obvious way, sometimes they are more opaque. I think working through photography, which both of us have chosen to do, we are aware that the visualisation of those issues are fairly transparent because the medium itself doesn't obscure information as much as if you were choosing a more plastic medium that wasn't so much geared towards representation. So you can't avoid references, but that doesn't mean to say that the approach should be trying to explain or illustrate an issue. I'm not comfortable with making work that is singular or becomes over instrumentalised.

LW | Rhetorically it could be suggested that artistic creativity is about thinking outside the box, looking around the sides of issues, bringing different perceptions to bear. For me, one of the criteria for evaluating art is whether imagery makes me think differently about something that matters.

JK | Yes, and something that actually affects you in some way so that it changes some aspect of your life experientially in some respect.

LW | Yes, even if only minimally

JK | Yes, its very important, in a small way, but its never going to change your life overnight, or only very exceptionally. But that isn't what you'd be looking for it to do.

CW | But it can also affirm. For me, it can strengthen a view that you have; maybe if you have an emerging notion of something that is relatively unexplored or undeveloped, seeing it and exploring it through the work can actually bring it on further. So it might not always make you think differently, It might actually empower you to think 'yeah, I am on the right track' because there is something affirmative emerging from it.

JK | In some ways it may just open questions up for you, make you think about them. This might not necessarily be just the 'issue' that is in front of you, but a quality of engagement that makes you think about whether or not the issue has any real concern for you.

CW | Relating that to *Futureland*, we were making work at a time when the Thatcher Government was saying that what they were doing was good for the country in terms of its regeneration policy aimed at changing the post-industrial landscape and its communities. Of course we all knew it wasn't, or at least some of us did. We were making work against

a tide, against a strong political tide. How true the sceptisism has proved to be. Look at where we are now with high levels of unemployment, social division just as extreme and a continuing lack of real sustainable investment outside some isolated high profile projects. I think the work we made back then did to a large extent empower people to develop critical positional views, to be saying 'look this ideological rhetoric about what is going to happen in a post-industrial society and in the North East in particular is questionable'. To question the assertion that the region will turn it into a consumer- and leisure-focused society as a legitimate replacement for work and that everyone is going to have more 'leisure time' an improved quality of life and so on, and so on. I mean we knew that there was just not going to be a quick fix to create a viable sustainable future.

JK | Yes, I think we try to find some of those kind of issues really because they start off as policies which are about some kind of social engineering or creating a particular type of society but so often it is just managerial and, beyond a sort of political ideology, it doesn't have very much of a political philosophy that's linked into any idea of what's interesting or what's good for people or the actual quality of people's existence; it's all about management. Thatcherism brought management into mainstream politics and effectively that is what we have had ever since. It's why now it's very hard, hand on heart, to say that what the Left and the Right are prepared to do is significantly different, one from the other.

And it seems to me that the idea of having a number of political choices has become a huge casualty. But it is something that we have to respond to, and I think that in a sense it is no longer possible to see the world in the way we did when we were much younger and perhaps more idealistically focused in some ways.

LW | You've mentioned three points that beg question. One is youth and idealism. The second is 'people' as an undifferentiated term, whereas people have very different experiences, and always have done, but particularly in the legacy of the Thatcherite culture of centralised control. The third reference is to the post-industrial and the ideal of a transformation to a consumer culture and leisure. In terms of regional economies, historically the industrial has been much more significant in certain parts of the country than others; it follows that a post-industrial transformation is going to have different and perhaps much more complex resonances in places such as the North East by contrast with, say, the South West.

JK | Nobody is taking that seriously. The current government's response has been to close the regional development agencies. Unemployment in the North East is running away, for example, we are losing four times the amount of jobs in the public sector than the rest of the UK. So there are real and terrible consequences of government policy at the moment, but there is no coherent strategy for putting that back. The real

number of the unemployed is probably four times the official figure depending which calculations you use. But if you return to the numbers that were so hugely doctored in Thatcher's time, many real jobs disappeared and there's no strategy in place to put those back, nothing beyond the hope that the private sector alone will somehow make things work, but they won't, or not without a convincing strategy for growth alongside a belief and commitment to the value and importance of the public sector.

LW | By 'real' job, do you mean a job that is productive in the sense of transforming materials in some way that makes them value-added in a classic Marxist understanding of the nature of the capitalist system? Are you contrasting that with some notion of a sort of softer job in, for example, the public sector or, for example, service industry?

JK | No, I wouldn't make that differentiation. There is another argument around production and capital, but I am just thinking in very simple terms: real jobs are jobs that provide enough income. They are not half-time at minimum pay rates – that's not a real job in a way because you can only just about keep body and soul together but you can't do all the things that our culture is expecting you to do – to consume at some kind of reasonable level, buy a house (because there are no or few houses to rent anymore) and bring up a family – perish the thought! So you need a reasonable level of income to do those kinds of things. Basically we lose the statistics and think that the problem has gone away. But it

hasn't, it's just seething away there. And kids are being brought up in the North of England and they have to leave, there's nothing for them and it's a tragedy. I think there are serious problems here that have to be addressed. This is getting totally political, but the fact that the current government does not represent the North of England or Scotland is actually placing the North back into this position where it feels a kind of desperation. Recently I have heard arguments for a regional assembly. The fact that Scotland is talking about independence reflects pretty much the same problem – effectively they're ruled by public school boys from London.

CW | We are getting into a more focused discussion around politics, economics and ethics than maybe we should be at the moment. Yet that agenda is critical to the motivation behind the work that we do. We are not politicians in the sense that we don't formally represent constituencies of people but there has to be a point where you use all of that information as well as your personal belief structures as motivation for making work. For me the issues are primarily about the making of the work, not whether we can directly influence political strategy and thinking. The issues that are being brought to bear on what John's just emphasised highlight a set of dilemmas for how people live their lives with some kind of dignity and a baseline of provision is probably beyond the actions or responsibility of any single government regardless of ideological emphasis. It's to do with the whole global

intersection of economy and where influence is and that's not always in the realm of governments as the private sector has a key role to play as well. If we tackle all that then we are going to be here all night trying to put the world to rights, but I do think it is vital to get a sense of that global agenda as a kind of baseline that runs through the focus of our work. The conditions in 2012 are not that different to the conditions in the late 1980s. The same issues of class divide, economic divide defined by geography and cultural divides and unemployment trends still exist.

So in terms of the question, why are we doing this show now? Part of the reason is because the issues haven't gone away. The very thing that we saw happening in 1989 in terms of initiatives to reinvigorate a region, that whole regeneration rhetoric from people like Heseltine is not a lot different to rhetoric you now hear around the Olympics for instance, which is coming to London and the UK as we speak. There is part feeding frenzy and part hope that this one big bash will kick start a process that will help sort all our problems out. Of course it won't. Here we are still dealing with the North, looking at places that we looked at 20/30 years ago saying, actually very little has changed in terms of the social and economic orders and political neglect. The landscape might look a bit different but actually we can still see through pictures exactly the same kinds of issues.

JK | It's interesting I think because we talk about this as if it is a northern problem but it isn't of course. It is a problem about how we

perceive Britain as much as anything. Britain, even the idea of Britain, is something that is in contention at the moment, but it's not about London it's about all the other places really. London is a kind of island state in some way within the country. When you look at, say, Scotland, the idea of Scottish independence is expressing a very real frustration with the distance, in every sense, of the London administration. Britain is regional, but somehow wherever the problem is, it's seen as something you can fix in London. In the North East our participation in the Olympic games is somebody running though the town with a torch! Conceptually there is no sense of how a nation needs to function to be a coherent nation.

CW | There is a tendency to default to a sort of tribal subculture mentality when there is nothing that confidently holds us together. If you suddenly find that you can't believe in the Government, that you can't believe in the Monarchy, you can't believe in a whole number of things which are meant to be somehow representing the glue that says you are a nation, then you say let's have a Welsh assembly, let's have a Scottish assembly, let's have a North East assembly, let's call ourselves something that allows us to create an identity that we can control and is self-generated. That kind of fragmentation or dispersed identity makes us very vulnerable in terms of representation, in terms of being able to mobilise any kind of leverage on issues that affect our lives. What that does do at the same time however, is create incredibly valuable and positive local self-awareness

that allows people a kind of dignity and common purpose that they expect the state to respond to. Or expect a combination of state and a recirculation of private profit to provide investment and opportunity. If you talk about 'The North' then it's almost too easy to consign it as just another subgroup, as distant, a tribal notion, as different and as a stereotype. In this sense there are 'norths' all over the UK. There is a 'north' in Hastings on the south coast where I spend a lot of time, where you've got a high percentage of families, three or four generations, who have never worked. You have got unbelievably high levels of unemployment, single parents on benefit, a high percentage of social housing and mental health issues, and lack of serious investment, and so on. It's no different in that sense to places in the geographical north.

LW | You're talking about the political context that informs how you develop your practice but on the other hand you are saying your work is not directly translating a political context. You also say you can go back and work on the same issues because they haven't gone away nearly 30 years later, although the literal content of the image might of changed a little because what is happening at the mouth of the river is very different certainly than 30/40 years ago. How do you think about aesthetic strategies? You were both pioneers experimenting in the use of colour photography, John in your case in use of text within the image, Chris in your case exploring new digital processes. That your work seemed cutting edge in a sense enhanced the political; the aesthetic

John Kippin
SCOTLAND/ENGLAND, 2009/2012
Inkjet pigment print on paper 40 x 32"

reflexivity somehow feeds into the political reflexivity. How do you rethink that now 30 years later when the issues are the same the content of the images shifted but not necessarily as much as one might expect?

JK | Interestingly enough part of why Chris and I first started to work together on this was because social documentary was dominant and celebrated, and it tended to be black and white. It also tended to believe cause and effect: it accepted the idea that if I show you something that is unpalatable or complicated or difficult, something will happen as a result of my having photographed it. Now I don't think that we ever believed that; we were artist-photographers working with our sensibilities and our ideas, naturally incorporating our political views. I had been a painter, and studied fine art at Brighton Art School (now part of the University of Brighton), although when I arrived at art school I virtually gave up painting. At the time the dominant influence was conceptual art and people were starting to work with film, video and photography. Art school was very much a mixed bag for me, and I was also interested in musical things. But eventually I came back to making pictures and I think that is when I rediscovered photography. That neither of us had a regular photographic background or training meant that Chris and I weren't locked into a 12 x 10 black and white picture aesthetic so we were more interested in other ways of thinking about things both intuitively and intellectually. I think we felt that campaigning humanistic photography wasn't achieving what was claimed. Maybe

it was a kind of cynicism, but there was an understanding that can only take you so far and we need to develop new audiences, new ideas, new ways of talking about some of these issues, however they might translate.

CW | A bit like John I didn't go through a formal photographic education, I studied Fine Art specialising in sculpture at Sheffield Polytechnic (now Sheffield Hallam University). I then studied Graphic Design at Masters level at Birmingham Polytechnic (Birmingham City University) which gave me a very good technical grounding. I got very involved in the debates around photography, particularly in the way that it was being used by conceptual artists to record events that were performed or of a temporary nature. There the photograph became the only thing that existed as evidence, or residue, so in a sense it was pure documentary in its nature. It became a quite rarified artifact, very much on a par with the nature of a painting or piece of sculpture – so it was very interesting to see conceptual artists' work exhibited in art galleries as photographs, especially as very few photographers were exhibiting in art galleries in 1988. By then, there was a very strong tradition of specialist photographic galleries emerging which had come about through concerted pressure in the mid 70s and through the development of photography within the Arts Council in particular. So there were two parallel cultures: one was a photographic culture with strong specialist galleries, often very socially focused, and nationally networked; then there was the more established art gallery/museum culture

Futerland
Laing Art Gallery, 1989

within which photography was not so well established or represented. So both John and I found ourselves between both these sectors, not easily identified within the photographic social documentary tradition because we came from a different kind of register of interests, and not really being engaged within the art gallery sector. It was interesting that one of the things that we used as an argument for *Futureland* being shown at the Laing was that it coincided with the 150th anniversary of photography and we sort of politely asked the Laing if they knew that in 150 years they had never had a photography show.

For me, one of the reasons why I chose to print on canvas was that it was a slightly tongue-in-cheek way of saying, "Well if you have difficulty accepting them as photographs you can consider them as paintings because they're made with pigment on canvas." It was also in a more serious way, a marrying up of some of those emerging innovations in digital media with very traditional forms of representation through painting. So, on one hand, the pictures were new and radical and groundbreaking but on another they were very traditional. They were stretched on traditional painting stretchers and were printed on canvas, they were using inks they weren't using conventional photographic materials and they had a monumental scale.

LW | I remember them well – you called the canvasses 'Scanachromes'. Did you have to research how to do that on canvas? Also, was it the idea of a tongue-in-cheek reference to

the painterly tradition, particularly the North as represented in the Laing, that led you to research the idea of Scanachromes and being able to use canvas or did it happen in more roundabout way?

CW | There was a small group of artists including John Hilliard (one of John's lecturers at Brighton) who, like us, were pushing new areas of commercial technology, trying things out. Colour photography was relatively new anyway, obviously not in the commercial world, but in terms of how artists and photographers were using it. It was very much a case of finding out through the network that there was this new technology and the guys at Scanachrome in Skelmersdale near Liverpool were developing it, so why not go and talk to them. What was really interesting was that I was going into an environment as an artist wanting to make non-commercial imagery, and that environment was set up for purely commercial purposes. So you'd wait in line while they did a huge billboard for Hovis or Renault cars and then you were next in line and you were saying, "Well I would quite like to do a bit of colour manipulation here, and can we change the ink guns round here a bit?" and they were looking at me like I was an alien. I had always worked as an artist in fairly accommodating environments where you were around other artists or you were in an art education institution where it was accepted or even encouraged to do things in an unusual and challenging way. So to go into a factory and say, "can we just swap these colours round on the machine because

I would like to see what happens?", it was like complete anarchy. They got used to me eventually and over a period of four or five years we did some really interesting stuff. I think that my graphics background helped me to adjust and to communicate in their language and I got my sleeves rolled up and did much of the prep work in the factory as well.

LW | What's interesting within all of this is that you two found each other. How did you find each other?

JK | Well we found each other through an organisation called Spectro Arts Workshop. God know why it was called that, but it was a complex, publicly funded with print making facilities, photographic facilities, a gallery and music making facilities. There was an idea there – a philosophy if you like – that the Arts were for everybody and the Arts were to be taught and talked about and made available to people both as producers and consumers. It was pretty much in line with a lot of thinking at the time around community arts. For my own part, I'd been working commercially so I came to Spectro as the antithesis of what I'd been doing. To me, it embodied ideas of practice that were valuable, relevant and engaged with the community. Chris and I found ourselves working in the photography department, and we sparked off one another.

CW | We were both people who came to the North East from elsewhere. I think that's quite important as we didn't see ourselves

as part of an indigenous Northern culture, although I do come from Sheffield, which I've always considered to be part of the North. Over time, the North East became a place that we both felt very connected to through our work, and also through living and working there. We developed an understanding of, and enjoyed good relationships with, the photographic community, even though we didn't fully share the dominant approach to photographic practice. We gravitated more to the constituency of people who were exploring and merging practices around performance, time-based media, artists film and installation because that, for us, suggested much more progressive ways of thinking about image making and an enlarged context for dissemination and dialogue. If we had thrown our hat in with the documentary photographers and film makers of the region, I think all we would have done is helped to consolidate that tradition and somehow perpetuate it and if it was going to shift it was going to shift very slowly. Whereas, in the emerging performance, film and installation areas there was a lot more potential, more speculative thinking and really interesting theoretical debate. There was much more questioning of forms of production and the context for practice than was evident in the photography arena. The way in which photographic, film and media culture embraced, say, feminist discourses, was interesting, and really important questions, not just about gender but about class structures, identity, economic opportunities and the emerging area of cultural geography were being asked.

LW | And language discourses...

CW | Yes, language. All those things just seemed right as a contextual framework: John was working with image and text that linked absolutely to some of the discourses about identity and representation. I was making work that was questioning permanence and value and how to change and adapt to those changing debates in emerging practices, and so on.

LW | Since *Futureland* in 1989 you two have gone off on different tracks; this is the first time you've exhibited together again. Does the work that each of you have done in the intervening years relate to the original ways of thinking and visualisation for *Futureland* and, of course, the return to *Futureland Now*?

CW | Well, we've been looking at the original *Futureland* images and then laying them out alongside images that we're working on right now and introducing some key images made in the 25-year gap, then making some kind of linkage that isn't necessarily chronologically focused, but adds up to some form of continuity. When people see the actual exhibition or the publication there will be some very different approaches in my work than in the original *Futureland* pictures where an actor was formally placed in the pictures. In the intermediate period, very few images had people in them. The current pictures are again working with performance, working with people actually doing more formally structured things and using larger numbers of people than I did previously. So there is a continuum if you follow

it through, but the agendas are slightly different. I'm not making work about the post-industrial North East as such. That seems to be something that I have moved away from, not just because I physically moved away from the region. My work now is looking at broader issues, particularly ecological and environmental issues to do with land and resource use and how the way we live our lives is affecting the planet's ability to sustain human needs. More specifically, my recent work is about climate change, it's about the way we are screwing things up through over reliance on dirty energy – particularly oil and coal – and the effects of an out-of-control mass consumer culture which is driving the world economy. Those social, economic and political issues evident in the original *Futureland* exhibition are absolutely embedded in issues about environment and climate. The same imperatives, the same drive towards excessive consumerism, are responsible for the way we're messing up the planet. So there is continuity; it's not always a visual continuity but there is a kind of underlying set of values that characterises my work.

LW | One of the things I notice when I look across your work is the way in which the colour red turns up all the time. And another thing is the performative, for example, painting the water with a red torch. So I think there are some visual continuities and it would be interesting to hear you talk a bit about that.

CW | The red: well I suppose it has become a kind of signature, you know, "Oh that's a red

picture, it must be a Wainwright..."! Some of the origins of why I use red are fairly straightforward and others a little bit more complicated and harder to articulate. The red aspects of the image are potent signifiers. Red's a classic colour for signifying danger, for heat, for warning, its a persuasive colour that is hard to ignore and has a persistence which is not always comfortable.

LW | Love and passion?

CW | Yes, it's a very warm colour, it's kind of energetic. It is interesting you relate it to love and passion as I do feel highly emotional about the areas that I now work in, the high Arctic in particular. In other ways, the use of red... it simply goes back to my interest in history of art and landscape references, you know, how Constable used to put people wearing red in landscapes as a focal point, as a counterpoint to nature.

LW | As in the greens and browns of nature?

CW | Yes, and even more so with the work that I'm doing about environment. That kind of intervention into what's often portrayed as a natural world i.e. the green world by the 'civilised' world, by passions and by the kind of harm that people do. So you stick someone in a red jacket in a green landscape and it adds that kind of tension. More recently I have been using semaphore signalling using red signal torches. I do a lot of work now around the coast and at sea including looking at shipping movements, communications systems and codes.

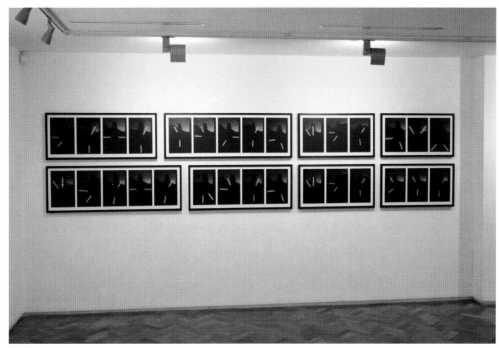

Chris Wainwright
Here Comes the Sun, There Goes the Ice
Disko Bay, Greenland, 2009
Digital prints on aluminium

John Kippin
Installation, Jaywick, Essex Martello Tower
Inkjet pigment prints on canvas, various sizes

LW | John your work has often been site specific in the years since *Futureland*. You've done a number of residencies and commissions. Do you see links between the specificity of a residency or commission and the more personal imperatives involved in working where you live?

JK | In a sense, it's always about the way you are in the world and how you respond to it. Perhaps because of my background, that was not one that would be fantastically familiar with art galleries for example, for me it is always about broadening audiences, engaging the kind of people with whom I identify, I suppose. So inevitably I have always thought about strategies needed to reach out to audiences that I want to have a dialogue with. All artists need an audience in order to communicate and complete the cycle of work. So there is a very practical side to me that wants to engage with problem solving, that's the first thing. And I have always found working on commissions stimulating, and it's an exciting challenge to complete that communication cycle.

LW | Can you illustrate that with reference to one or two commissions?

JK | The commission at Compton Verney in Warwickshire was a good example. Working in a place like Compton Verney was interesting because of what the house and estate represent in the public imagination, especially given that appeasement meetings were held there in the run up to the Second World War. So what it somehow represents

is an unattainable idea of Britishness. You've basically got an aristocrat's house representing somebody who believed almost in a divine right for the aristocracy to rule. And I was coming from a very working class socialist perspective. So for me to think about that was fantastic, while at the same time recognising the contradictions that come through education, so one could admire the architecture and the spaces and the works of art that those kind of people where able to put together and many things about the fact that they were so much in control of their own destiny in a way that my folk never were. So to take that on board and think about that in terms somehow of Britishness, of Englishness in my case, and how that kind of reflects on ones own identity was a real challenge. It's something that I might just read an article about otherwise. So to actually engage in it as a creative enterprise was a really positive and interesting idea.

LW | Or the lighthouse off the east coast?

JK | What those kinds of opportunities do actually is to enable you to pull together research that you might do and things you might be thinking about. Projects are quite discursive in a way. So I worked in a Martello tower on the Essex coast. When I started, I was thinking about what structures might be made to defend a border line: the Essex coast, OK, it's close to France, it's a likely place for invasion from Napoleon onwards. Well I started to think about that and about the coastline as a border, and then it began to change into considering it as a place that

was actually defining identity, particularly in terms of the fact that the English aristocracy descended from the French aristocracy, and through invasion significant historic changes occurred. So the work I made was to try and think about that in a more contemporary context, about how we define our identity though a number of things. Those things include the land that we occupy, the places and the spaces that we claim as somehow intrinsic to our being. And of course, like anything to do with identity, the harder you look at it, the less watertight it becomes as an idea, the more slippery it becomes as a concept. So I wanted to think about nationality and about identity and to realise that these things are really just political expediencies that are extraordinarily mobile and used for all sorts of reasons, mostly not very good ones.

LW | That's really interestingly, because one of the things you've both said consistently about *Futureland Now* as a project is that, although the focus is a return to the North East, the North East is acting a sort of fulcrum for trying to understand something that is international, indeed global. What you're just pointing out is this is nothing new. But do you see this as operating slightly differently in the Internet age and what new challenges are there about the *globalness* of internationalism now that maybe weren't quite so evident in the late 1980s in the first *Futureland* investigations?

JK | I think one of the truly frightening things is that the smallest changes in one place can

have an immediate effect elsewhere. Despite the interim 25 years during which time cultural sectors developed, no one has begun to address the real problems that are far more structural and far more complex; and yes, they apply across the world. So part of what *Futureland* achieved was thinking of the North not just as a place but also as a measuring device for testing the temperature of satellite states and their relationships to power. But how can we understand a place that was created around a specific function that it no longer fulfils, and how is this rolled out across, not only the UK, but everywhere?

CW | I guess I started to think about these types of issue in a slightly different way. There are all kinds of imperatives about addressing social inequality or financial inequality and the kind of difficulties that many people have just leading a dignified life, and so on, not just in the UK but worldwide. For me there is a new overriding concern that is bigger than all of that, namely the way that collectively as a human race we are destroying the planet that's supporting us. And I just think that it's such an abstract issue that I don't think it's been collectively addressed seriously enough. Or if it is being taken seriously it requires such a seismic shift in attitudes to do anything about it that little happens. I'm not trying to be doom laden about it, but I do think that unless there are some fundamental changes in the way that people live their lives then there are going to be some really catastrophic times ahead that are going to happen much quicker than people predict.

LW | Yes, and this is global, so the North East is merely one place that will be affected. But this wheels us back to the question we touched on earlier: as artists what can you do in relation to that? The image that John evoked of art merely being a way of dripping a bit of water on the stone is very vibrant; if you drip water on the same stone for a long while you gradually penetrate that stone. Is that what keeps you making work?

CW | For me it's because that's what I do. I have chosen to work as an artist and educator and operate within the expanded parameters of what is possible in those contexts, It's as simple as that.

LW | But why do you go on doing it, you could stop doing it?

CW | Well I could stop doing it but I'm not sure that I could find a better mechanism to express the way I feel about things and I still get very excited about image making.

LW | It's interesting you use the term 'feel' because feeling relates to poetics as well as intellectual analysis.

CW | Maybe it was an immediate term that I used but I think that part of my practice comes substantially from a British fine art landscape romantic tradition. I was brought up in rural Derbyshire, where I lived for part of my life on a farm, where a lot of early influences and life experiences came from. My early experience as an artist was also through painting. Its interesting that three

of my recurring artistic reference points are Joseph Wright of Derby, Samuel Palmer and John Martin. Ironic that Martin has such a strong relationship to the Laing Art Gallery. In fact I have titled one of the new works in the show after one of his paintings, *The Great Day Of His Wrath*. It's a kind of end of the world vision as we descend into hell surrounded by flames and damnation. I made the new piece on Teesside against the backdrop of heavy industrial out pouring.

LW | The Romantic movement first emerged just in advance of industrialisation, which is probably not at all coincidental. Romanticism was about getting away from what we were causing and if you were aristocratic or upper middle class and affluent, you went to Greece or Italy and reflected on places that were the pre-industrial. So actually I think there is a very interesting discussion to have there.

CW | It is interesting, but it takes us away from discussing tactics, what do we do and why we do it. Although we are seeing right now in terms of climate change, dramatic affects on the planet's eco systems that can be traced back to the industrial revolution as the point of significant escalation.

LW | And why go on trying to do it? None of us are any longer in our early 20s, fresh and enthusiastic or just emerged from art school!

JK | I think art chooses you, rather than the other way round; artists need to make things in order to make sense of their lives so it becomes a question of well, what do you

make things about? I have often thought that in my case if hadn't become a photographer it wouldn't really matter as I'd do something else, perhaps drawing or painting, but I would still be asking myself the same questions but approaching them in different ways.

LW | So you are talking about thinking through making, about the necessity of a tactile approach to things.

JK | Yes, the materiality of the process of thinking through making things is absolutely essential to making art. And as Chris has said about feeling, well you can't always identify what those things are and how they motivate you, but you are responding to them all the time. As I said earlier, ideas of value and virtue are tied up in the process as well. So it's complex in the sense that you could say OK, there is a political problem, so I'll make some work about it and address it, but that probably wouldn't really be your primary motivation.

CW | I agree, I never approached making work in a singular way or about a specific issue without a real concern for the whole process of making an interesting or engaging image in its own right. I've felt very strongly about things and events, like the miners' strike in 1984–86. That was something happening in the community I was brought up in and around Sheffield, then called the Socialist Republic of South Yorkshire and I saw what damage was being done to whole communities and families. I basically witnessed, along with the whole nation, the effects of the British 'civil war' initiated by the cynical Thatcher

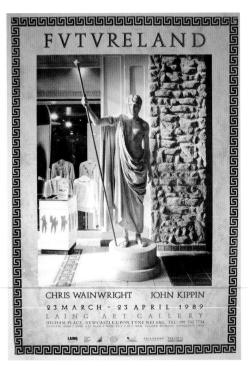

Exhibition poster for *Futureland*, Laing Art Gallery, 1989

Government declaring war on the British working classes, I felt very, very strongly about it, yet I didn't make one single piece of work that addressed those issues. But it was there, it was like a constant prodding, a constant motivation to continue thinking, looking, questioning and absorbing in a way that would motivate my practice.

Over the past few years, I've spent some time in the High Arctic looking at climate change with a group of scientists. The work I've come back with is not the type of work that's going to get used in a campaign or that people look at and go, "Yeah, we really are screwing things up aren't we?" What they might do is look at the work and be absorbed by the heightened visual impact of the image. Because in the end, as I said earlier, I think there is a role that the artist has and there is a role that the art has, as it becomes independent of the artist and you've got to somehow allow those two things to take their separate paths and allow people to bring their own meaning and interpretation to the work.

LW | You are both university professors working in an art education context, which surely informs our various approaches in some way.

CW | Yes, I think it's really important that we both spend a lot of our time as educators as well as being artists and that's been a conscious career decision on both our parts. And if you go back to the question about motivation it is also to inform our position and responsibilities as educators.

LW | Responsibilities as educators to do what?

CW | To be in a position of – well not so much authority, because knowledge essentially is relative – but to have something that is substantially resolved or well argued that you can take into an educational context, that can be of use to other people, so that they might actually see that what you're doing, what you're saying to them and where you're coming from has a kind of validity. So, for me, being involved in education as a teacher, a leader and a manager, as a person who can have some influence over education has been really vital to maintaining an absolute belief in and commitment to practice.

JK | I would support that, it's interesting, curious how one's work is referred to and used by other people and also that you can never control this, including the way it's accessed by students and what they feel is the virtue or value for them in it. In a sense, being in education puts you into a continuous debate where you are always reflecting on and considering your ideas and, hopefully, refining and challenging them. That's a fantastically fertile environment. As Chris said, that's part of who we are and part of what we're very happy to be. In a sense, it is also indicative of the role that we see for the work and some of the ways that it goes out into the world. It's not static, it will have different interpretations and different meanings and different contexts, so I see education as part of that very dynamic ongoing context. I hope we will be talking

about this exhibition and this book, not just in the near future, and part of doing so will be to ask people what they think of it and to build something around their responses.

John Kippin

Chris Wainwright

John Kippin is an artist and photographer who largely works within the broad context of landscape. Many of his pieces integrate texts with images in ways that offer commentary on, and frequently challenge, the realist paradigm that traditionally underpins a range of documentary practices. John Kippin pays allegiance to the traditions of pictorial landscape, while foregrounding issues within contemporary culture and politics. In addition to gallery exhibitions, he has produced a number of public art works in a range of media and publications. Recent books include *Local* (with Henry Kippin) and *He* (with David Chandler). He has worked on numerous commissions including *Cold War Pastoral* based at Greenham Common, Berkshire, *Compton Verney* in Warwickshire and *Coast* situated in a Martello tower in Jaywick, Essex. His work has been widely exhibited both in the UK and overseas and is in many public and private collections.

John has been associated with Locus+ for many years and is a member of the Board of Trustees. He was also chair of the Association of Photography in Higher Education, 2008–2011. He has contributed to numerous academic conferences and symposia and has an MA and a PhD from Northumbria University. He is Professor in Photography at the University of Sunderland.

Chris Wainwright is an artist and curator, working primarily in photography and video. His recent exhibitions include: *Futureland Now* at the Laing Art Gallery, Newcastle, UK; *Between Time and Space*, Heijo Palace, Nara, Japan; *The Moons of Higashiyama*, Kodai-ji temple, Kyoto, Japan; *Between Land and Sea* at Box 38 Ostende, Belgium; and *Trauma* at the Culturcentrum, Brugge in Belgium. His work is on show as part of the UK touring exhibition *Fleeting Arcadias* – Thirty Years of British Landscape Photography from the Arts Council Collection.

His time-based work *Capital* has been shown at 'File 2002' and *Channel 14* at 'File 2005' in Sao Paulo, Brazil and video projections at the Champ Libre Festival of Electronic Arts, Montreal, 2004 and 2005. *Channel 14* was also selected for the Media and Architecture Biennial, Graz, Austria 2005.

He is co-curator of a major international touring exhibition for Cape Farewell called *U-n-f-o-l-d* which profiles the work of 23 artists, addresses issues of climate change. The exhibition has been shown in Vienna, London, Newcastle, Newlyn, Liverpool, Chicago and New York. He is also the curator of a selection of work by UK artists to be shown in a major survey of art and science work at the Science and Technology Museum

in Beijing. He is editing a forthcoming publication on expeditions.

His photographic work is held in many major collections including the Victoria and Albert Museum, London; The Arts Council of England; Bibliotheque Nationale, Paris: the Polaroid Corporation, Boston, USA; Unilever, London; The Laing Art Gallery, Newcastle, and MIMA, Middlesborough.

Chris Wainwright is Professor and Head of Camberwell, Chelsea and Wimbledon Colleges, the University of the Arts, London. He is a member of The Tate Britain Council and Chair of the Board of Trustees of Cape Farewell, an artist-run organisation that promotes a cultural response to climate change.

Liz Wells writes and lectures on photographic practices. She edited *The Photography Reader* (2003), and *Photography: A Critical Introduction* (2009, 4th ed.) and is also co-editor of *photographies*, Routledge journals. Her many talks and publications on landscape include *Land Matters, Landscape Photography, Culture and Identity* (I.B. Tauris, London, 2011).

Recent exhibitions as curator include *Sense of Place, European Landscape Photography* (BOZAR, Brussels, 2012); *Landscapes of Exploration*, contemporary British art from Antarctica (Plymouth, 2012); *Chrystel Lebas and SofijaSilvia – Conversations on Nature* (Rijeka, Croatia, 2011); *Facing East, Contemporary Landscape Photography from Baltic Areas* (UK tour 2004–2007),

She is Professor in Photographic Culture, Faculty of Arts, University of Plymouth, UK, and convenes the research group for Land/Water and the Visual Arts.
www.landwater-research.co.uk

Mike Crang has longstanding interests in social memory and heritage, examining the practices of public history, photography and museums. Concern for the consumption of landscape through visual media led him to work on the intersection of film, photography and tourism – including a case study using the novel and film *Captain Corelli's Mandolin* and Cephalonia. From the angle of visual aesthetics and senses of temporality and rhythm, he has become interested in not just issues of preservation and conservation but also their converse – destruction, dereliction and decay. He has written and edited nine books, and is currently writing a book *Wastescapes* to be published by I.B. Tauris, London.

He is a Professor of Geography and Associate Director of the Centre for Visual Arts and Cultures at Durham University.

Hardback edition first published
in the United Kingdom in 2012 by
University of Plymouth Press,
Roland Levinsky Building,
Drake Circus, Plymouth
Devon, PL4 8AA
United Kingdom.

ISBN: 978-1-84102-323-6

The rights of John Kippin and Chris
Wainwright as the authors of this work have
been asserted by them in accordance with
the Copyright, Designs and Patents Act 1988.

A CIP catalogue record of this book is
available from the British Library.

Editor: Liz Wells
Designer: Dean Pavitt | loupdesign.co.uk
Copyedit: UPP

Printed and bound by Short Run Press,
Exeter, United Kingdom.

Acknowledgements
Many thanks to Julie Milne, curator of
exhibitions at Tyne and Wear Museums, for
facilitating this project, to The Arts Council
of England for production funds, and to
Dean Pavitt, book designer.

John Kippin would like to thank
the following for their support and
contribution to realising *Futureland Now*:
Sam Peace, Helen Kippin, Dr Carol McKay,
Amanda Ritson, Mike Collier, The Tyneside
Cinema, John Laidler (The Rip, Newcastle
upon Tyne), Paul Gallagher and Claire Turner
(framing), Digital Lab, Newcastle upon Tyne.

Chris Wainwright would like to thank the
following for their support and cooperation
in imagining and realising *Futureland Now*
and related work: Reuben Kench,
Karen Lydiat, Gen Ide, Craig Campbell,
Zhang Bo, Bill Coates, Robyn Hitchcock,
Craig Rowatt, Sharon Vickers, Kate Sedwell,
Michael Dyer Associates, A.Bliss and
Anne Lydiat.

Liz Wells would like to thank Kate
Isherwood, M Res., for her support in
reading and commenting on all the texts.

University of Plymouth Press